IMAGES
of America

WHITE ROCK
LAKE

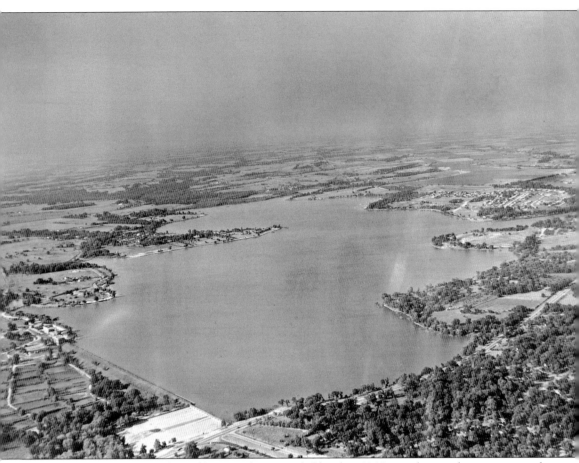

Looking north from the spillway to the open fields, this 1948 aerial view shows a tranquil White Rock Lake that has become an oasis in an urban environment. Behind the dam is a fish hatchery that was built in 1930, and at the end of the dam is the pump house and filter building. On the eastern shore is Winfrey Point, and behind the point is the old Civilian Conservation Corps camp. (Courtesy of Dallas Municipal Archives.)

ON THE COVER: In 1938, people came from all around the Dallas area and gathered on the shore of White Rock Lake at T&P Hill to watch the speedboat races. Across the cove on the hill, one can see one of the lake's most famous residences—H. L. Hunt's Mount Vernon. (Courtesy of Dallas Municipal Archives.)

IMAGES of America
WHITE ROCK LAKE

Sally Rodriguez

Copyright © 2010 by Sally Rodriguez
ISBN 978-0-7385-7883-5

Published by Arcadia Publishing
Charleston, South Carolina

Printed in the United States of America

Library of Congress Control Number: 2009934865

For all general information contact Arcadia Publishing at:
Telephone 843-853-2070
Fax 843-853-0044
E-mail sales@arcadiapublishing.com
For customer service and orders:
Toll-Free 1-888-313-2665

Visit us on the Internet at www.arcadiapublishing.com

This book is dedicated to all the citizens of Dallas who have made White Rock Lake a part of their lives.

Contents

Acknowledgments 6

Introduction 7

1. Development of a New Water Source for Dallas: 1909–1929 9
2. From Water Source to Park: 1930–1942 31
3. World War II and Post-War Years: 1943–Present 79

Acknowledgments

I would like to thank all of the City of Dallas employees in the Dallas Park and Recreation Department and Dallas Water Utilities who came before me and were pack rats. Without their efforts to save everything, I would not have had any of these treasures to find and share.

I greatly appreciate all of the guidance and support I receive from Willis C. Winters, FAIA. Willis allows me to do the research that he would love to have the time to do himself and is always excited with each new picture or story I uncover. This collection of images would not have been possible without the assistance of John Slate, city archivist, who allows me full access to the municipal archives and has taught me so much.

To my family and friends, thank you for being patient with me as you smile and pretend that you are still interested when I have repeatedly shared all of the stories I have uncovered.

Unless otherwise noted, all images appear courtesy of the Park and Recreation Department Collection of the Dallas Municipal Archives and the Dallas Water Utilities Collection.

Introduction

Public parks have been important to the quality of life for the citizens of Dallas since the purchase of its first park in 1876. Today the City of Dallas park system consists of over 350 parks and more than 18,000 acres of land. White Rock Lake is a jewel in the crown of the Dallas park system. Even though White Rock Lake began as a water source 10 miles outside the city limits, today it is an urban oasis that is enjoyed by over two million visitors a year.

In 1909, the city of Dallas was experiencing rapid growth, and the area was in the midst of a multiyear drought. City leaders decided it was time to develop a new water source in order to meet water consumption needs for years to come. They chose to purchase land along White Rock Creek east of Dallas. Construction was completed on this new water source in 1911, and within 15 years, the city's need for water had outgrown White Rock Lake. Lake Dallas, a larger lake farther outside Dallas, was opened in 1929, and White Rock Lake was no longer needed as a water source. In December 1929, Dallas City Council took action that transferred the land surrounding White Rock Lake to the Dallas Park and Recreation Department to maintain as a public park.

Even though it was not officially a park yet, citizens had been using White Rock Lake for picnics, swimming, fishing, and hunting since the lake had been developed. With the transfer of the land to the park and recreation department, the development of recreational amenities occurred quickly. In 1930, a new picnic shelter, boathouse, and bathhouse with bathing beach were developed. In 1935, the Civilian Conservation Corps (CCC) came to White Rock Lake. These young men built roads, concession buildings, restrooms, community buildings, a shelter house, and a lily pond, as well as planting thousands of trees around the lake. It was the efforts of these boys in green that created the park enjoyed by millions today.

When the United States entered World War II, the Civilian Conservation Corps was dissolved. The old CCC camp, which had been built by the U.S. Army, was first used as an Air Corps boot camp. It later became a branch camp of the Mexia, Texas, POW camp used to house German officers captured in Africa who had been part of Rommel's famed Afrika Korps. After World War II, Southern Methodist University experienced a large influx of male students, and the university did not have enough dormitory space for all of the men. The old CCC camp was utilized for overflow housing and nicknamed Perunaville after the SMU mascot, Peruna. The CCC camp stood for 15 years, but by the end of 1950, all of the camp buildings had been dismantled, moved, or sold. Two of the barracks were sold and moved to the Forest Hills neighborhood for housing. The recreation building was moved to Exall Park and used as a community recreation center until 1991. Two of the buildings were moved to Sunset Inn and used for storage. The wood from some of the buildings was used to build a basketball court in the automobile building at Fair Park. The only remnant of the camp is a fire hydrant near the baseball diamond at the former site of the camp.

The next few decades brought more floods and droughts, and by 1994, the Dallas Morning News ran a series on "The Death of an Urban Lake." The articles predicted the death of White

Rock Lake if the city did not properly care for this exceptional facility. Since that time, the city has dredged the lake once again and begun to restore many of the historic facilities, while adding and updating recreational amenities.

When White Rock Lake was built, it was miles outside the city limits, surrounded by farms and open fields. Today White Rock is an urban oasis in the midst of numerous neighborhoods and a thriving city. Throughout the decades, so much of the life and history of Dallas is tied to the life and history of White Rock Lake, just as White Rock Lake is tied to the lives of its visitors. White Rock Lake is part of everyone's own personal history, whether they went to White Rock Lake as a child with their family, enjoyed the lake with their sweetheart, took their own children to the lake, or just enjoyed the flora and fauna.

One

DEVELOPMENT OF A NEW WATER SOURCE FOR DALLAS
1909–1929

By the early 1900s, Dallas was a growing city with an ever-increasing need for water. City leaders decided to impound White Rock Creek to create a new lake about 10 miles northeast of town. In 1909, city commissioner of streets and public land William Doran and purchasing agent M. H. Mahan began purchasing the farm and forested land along White Rock Creek. By March 22, 1910, they had purchased 2,292 acres of land at a cost of $176,420. The city engineering department drew up the plans for the dam and pump station. Fred A. Jones Company received the construction contract for the dam and spillway on March 8, 1910. As construction began, the city harvested and sold the crops on the new land, but they did not sell the wood from the trees that were removed. The city welfare department distributed the wood to the poor for heating and cooking fuel.

The dam and spillway were completed and closed off on June 24, 1911. Everyone anxiously waited for the water to rise, but because of the continuing drought, the lake did not fill until April 14, 1914, at which time the water was 42 inches deep over the spillway. The foundation for the pump station was poured during construction of the dam and spillway. In November 1910, construction for the new pump station was contracted to Hughes O'Rourke, and it was completed in 1911. White Rock Lake was gauged to hold 5.8 billion gallons of water, which was enormous at the time compared to the less than one billion gallons held on the Trinity supply. White Rock water was the first chlorinated water in Dallas. It was not clarified or filtered, but chlorination was a giant step forward.

Dallas continued to grow, and before too long, the city limits extended out to White Rock Lake. The new growth also meant an increased demand on the water supply. City leaders originally believed that White Rock Lake could be the major source of water for Dallas for 100 years, but by the mid-1920s, the need for water surpassed the supply provided by White Rock. In 1929, a new, larger lake was completed further north in Lewisville, Texas, and White Rock Lake was no longer needed as a water source.

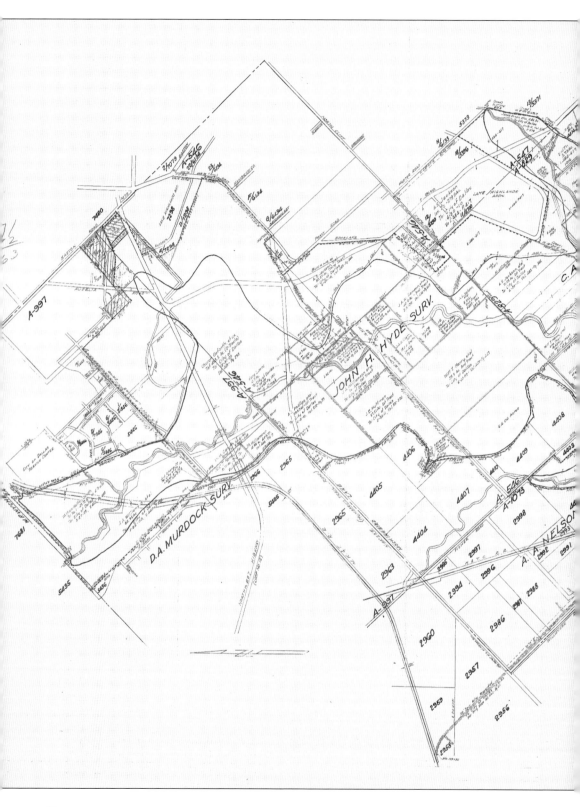

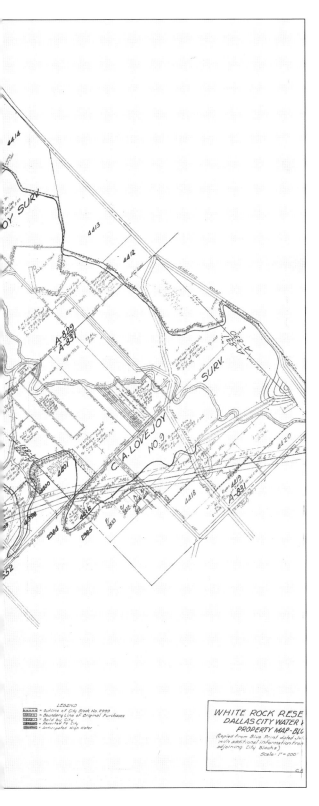

The city began purchasing land for the new reservoir in February 1909. It took nearly a year to complete the purchase of land. Some of the landowners were Charles Fisher, William McCommas, William W. Caruth, S. H. Fisher, J. A. Williamson, Church Goforth, and Jacob Dixon. Construction of the lake forced the realignment of several major streets through this area.

William Doran (1847–1931), city commissioner for streets and public lands, was responsible for negotiating with all of the landowners to purchase the 2,292 acres that would become White Rock Lake. Doran's Point on the north side of the lake is a tribute to him.

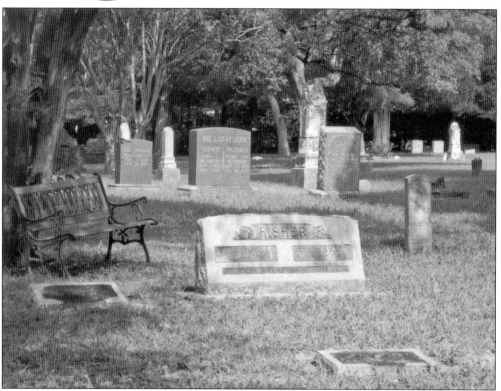

Many of the prominent families from the area, such as the Fishers, Dixons, and Williamsons, are buried at the Cox Cemetery. Cox Cemetery dates back to 1879 and is located on Dalgreen Drive. Dalgreen Drive was originally the highway that ran between Dallas and Greenville, Texas, and went across the northern end of White Rock Lake. It is purported that the "Lady of the Lake" is buried in Cox Cemetery. The Lady of the Lake is a popular folk ghost story.

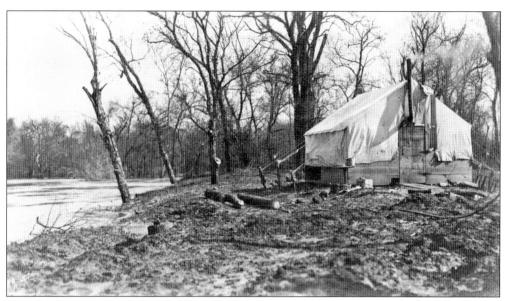

A workers' tent was set up beside White Rock Creek as work began to clear the land for the new lake. In 1910, this area was so far from any city that the workers had to be housed on-site.

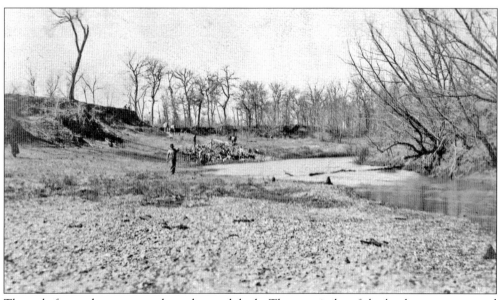

The only forested areas were along the creek beds. The remainder of the land was pastures and fields, and as construction began, city forces harvested and sold the crops.

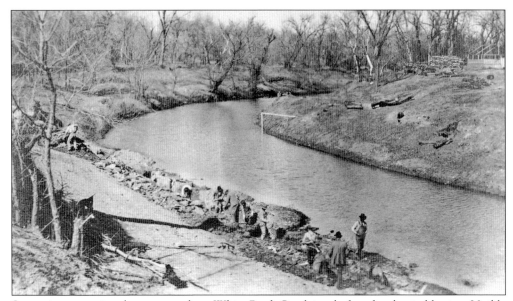
Supervisors examine the progress along White Rock Creek just before they begin blasting. Visible in the upper right corner is wood stacked for distribution to the poor.

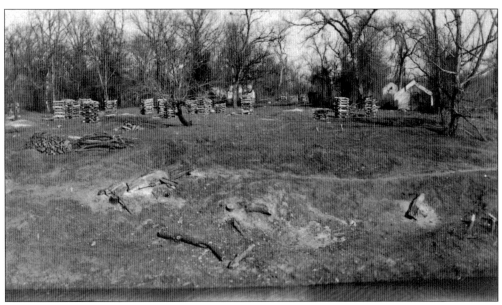
More wood is stacked along the creek. The city did not sell the wood but distributed it through the city's welfare department for heating and cooking fuel.

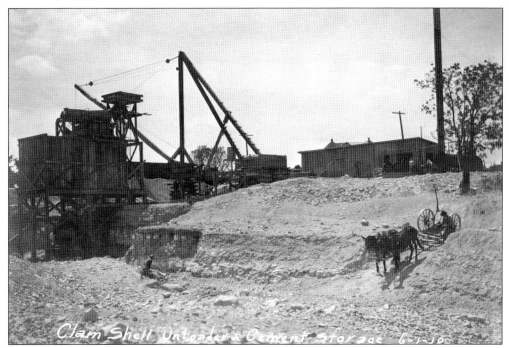

This June 1, 1910, photograph shows the clamshell unloading and cement storage area for the dam and spillway construction. The area does not have very much topsoil; the limestone, or white rock, is clearly visible in this image.

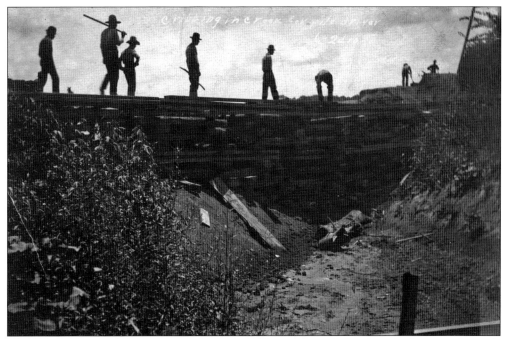

The men of the Fred A. Jones Company are cribbing the creek for the pile driver on June 12, 1910. To crib is to stack lumber or build scaffolding that will allow the pile to be driven across the creek bed.

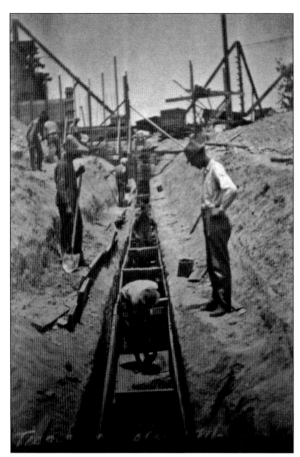

Men are beginning the trenching for the intake well. In the background, the walls of the dam begin to rise.

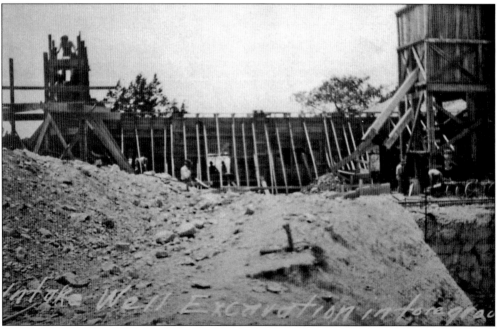

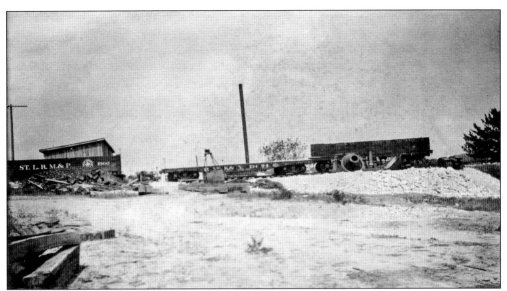

It is well known in the area that a spur of the Katy Railroad was used to bring coal to the pump station. This 1910 photograph shows that the Katy spur was used to bring supplies into and carry debris out of the dam and spillway construction site. The last railroad car on the left is a St. Louis, Rocky Mountain, and Pacific Railway car, and the trademark is a swastika. Before Nazi Germany's use of the symbol in World War II, the swastika was a very common symbol in the United States.

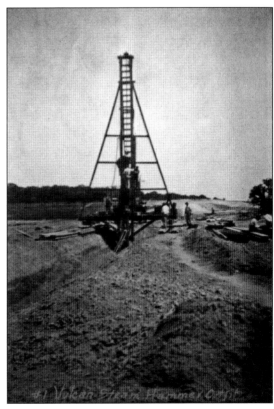

Pictured here is the No. 1 Vulcan Steam Hammer. Since there was no electricity to operate the jack hammers, it was necessary to generate steam power.

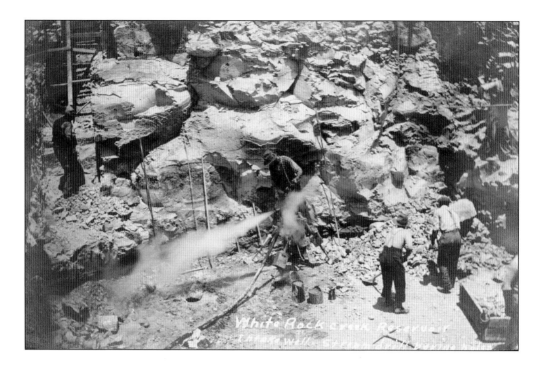

Crews are using a steam jackhammer to cut through the limestone for the intake well. Notice the fancy ladder in the upper left hand corner used to access this area. It is obvious from this image why the area is known as White Rock. Below, workers haul the rock out of the hole.

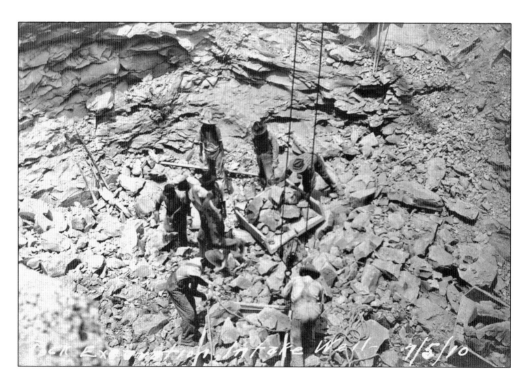

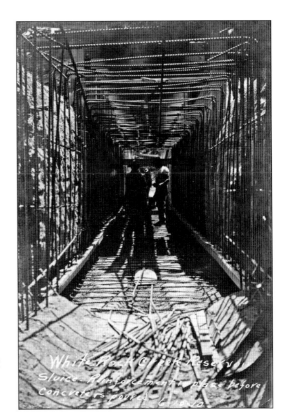

A sluice box is used to filter out large debris from the water as it enters the pump station. The 1910 photograph at right shows the framed sluice box awaiting concrete. The photograph below shows the sluice box after the concrete has been poured and the frame removed.

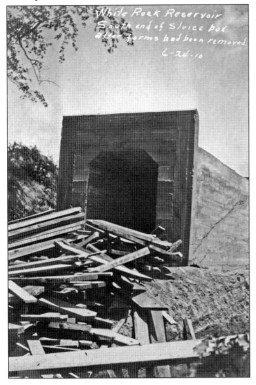

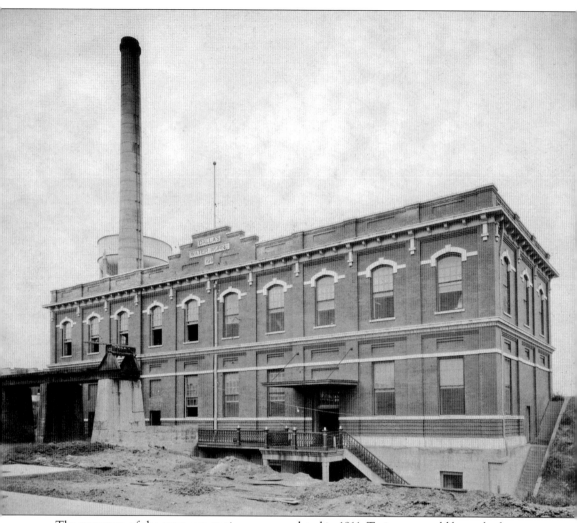

The new state-of-the-art pump station was completed in 1911. Train cars could be pushed out onto the railroad trestle to the left. Trap doors on the cars would be opened and the coal would drop to the ground directly in front of the boiler room. Staff at the pump station would then shovel the coal directly into the boiler.

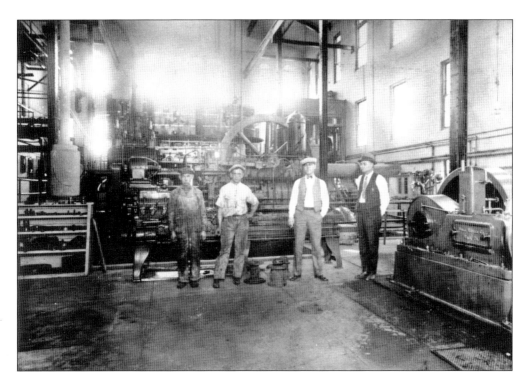

The photograph above reveals the interior of the pump station at White Rock in 1911. The pump station had three boilers driving two turbine pumps. One of the original pumps is seen below.

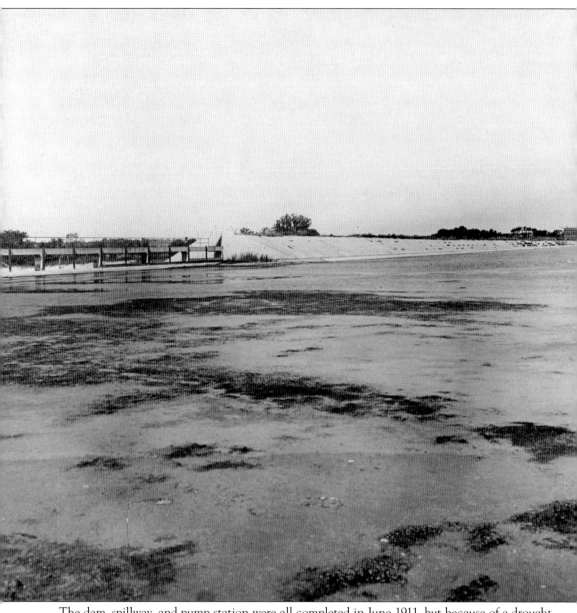
The dam, spillway, and pump station were all completed in June 1911, but because of a drought the lake did not fill until April 14, 1914. When the lake finally filled, the water was 42 inches deep

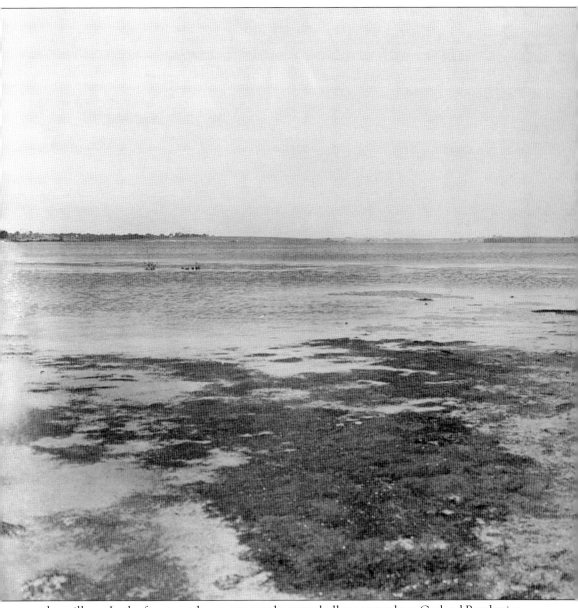
on the spillway. In the foreground, one can see the very shallow water along Garland Road prior to the lake filling completely. In the background are the pump station and its smoke stack.

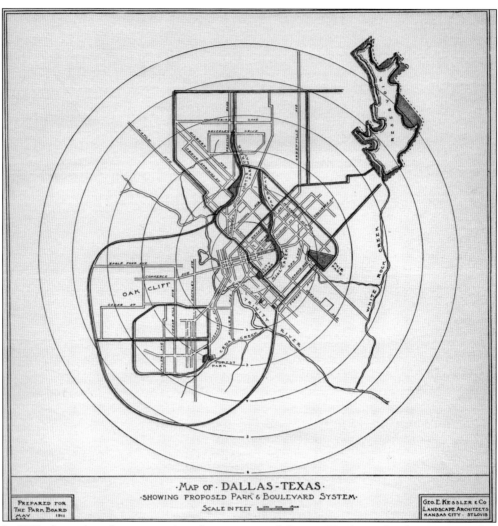

In 1911, the park and recreation board commissioned George Kessler to develop a master plan for Dallas. White Rock Lake is shown in the upper right corner of the plan, approximately 10 miles from the outskirts of the city. In the plan, Kessler states that by incorporating this great water basin as a part of White Rock Park, Dallas would have one of the great park properties of the country.

This page from the 1921–1923 park and recreation board annual report lists White Rock Lake as a suburban park. The lake was still several miles outside the city limits of Dallas. The top image is of the northern area of the lake known as Doran's Point. Today this area is near the intersection of Buckner Boulevard and Northwest Highway. The aerial picture is from the north facing south. In the foreground is Doran's Point. The first peninsula on the left is Boy Scout Hill, where Mockingbird Lane crosses the lake today.

Joe E. Lawther was a prominent Dallas bank executive and was mayor of Dallas and Dallas Park and Recreation Board president from 1917 to 1919. It was through his efforts that White Rock Lake became one of the city's beauty spots.

A roadway system was built around the edge of the lake and was named for Joe E. Lawther.

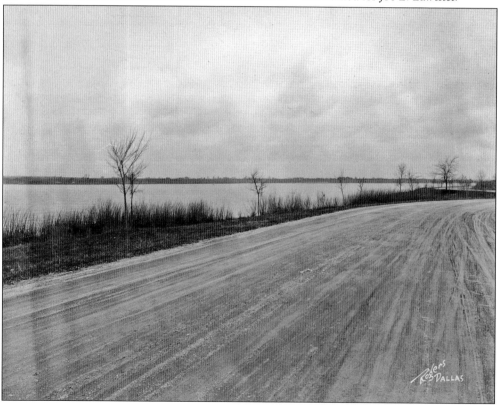

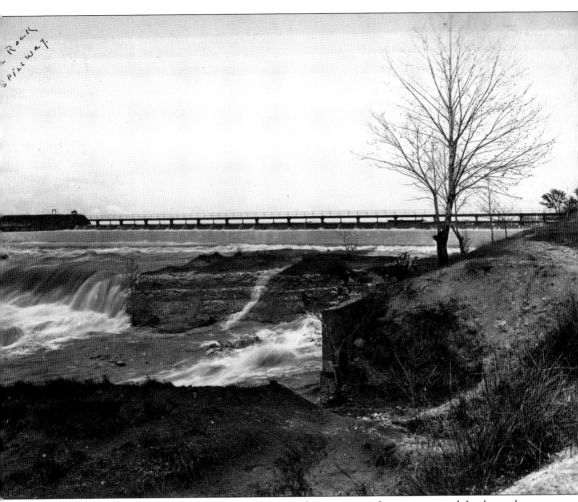

The spillway has been a popular location to photograph since it was first constructed. In the early years, people were allowed to swim in this area. When the spillway was originally constructed, there was a walkway across the top. A flood in the 1960s washed this walkway downstream.

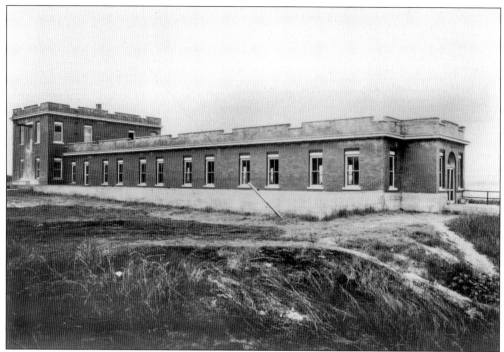

The filtration building was added in 1923 just north of the pump station. Until that time, the pump station had been pumping unfiltered chlorinated water into town. Below, the interior of the filtration building is seen during construction in 1922.

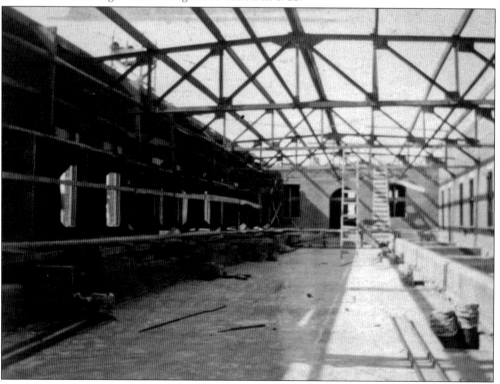

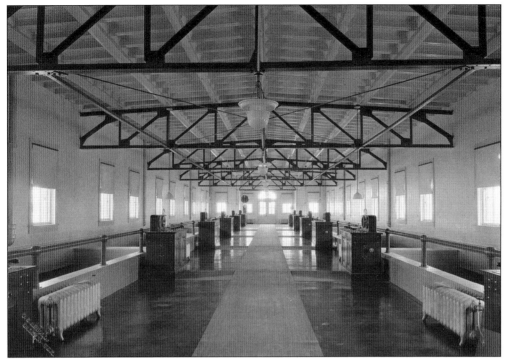

The interior of the filtration building, known as the filtration gallery, still shone like new in 1924. Today this gallery is available for private rentals, with an outside deck that overlooks the lake.

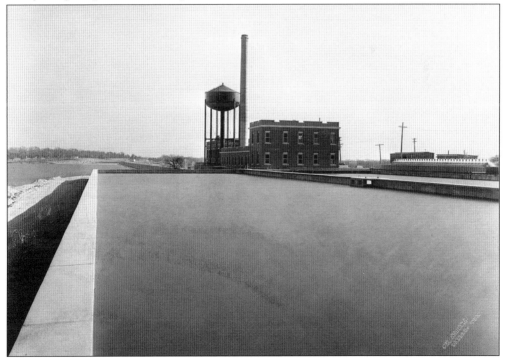

In 1923, these two filtration tanks were added, with a capacity of 2 million gallons each. They increased the storage of treated water and made it easier to meet the area's growing needs.

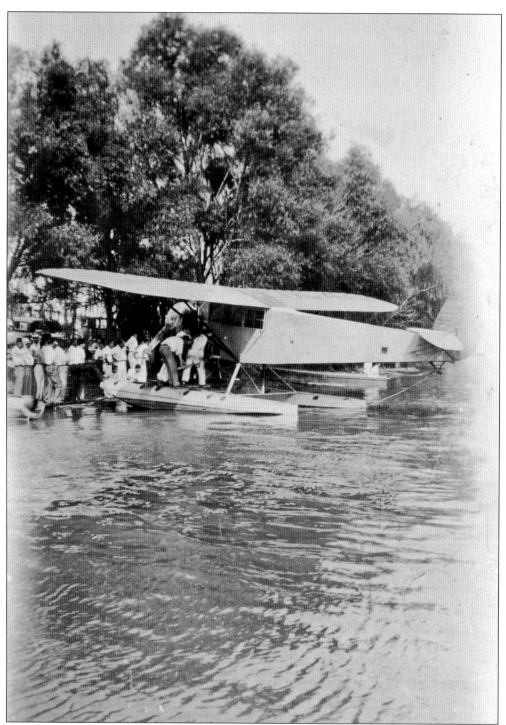

A moonlight ride among the clouds was the newest sport at White Rock Lake in July 1929. This photograph shows Henry Toncray with his seaplane on White Rock Lake. Other amphibious planes had landed at the lake, but this was the first seaplane. (Courtesy of the Texas/Dallas History and Archives Division, Dallas Public Library.)

Two

FROM WATER SOURCE TO PARK
1930–1942

In December 1929, the Dallas City Council took action to transfer the responsibility of the land surrounding White Rock Lake to the park and recreation department. Dallas Water Utilities remains responsible for maintaining the water, dam, and spillway. The city moved quickly, and on August 9, 1930, the new bathhouse and bathing beach opened on the east side of the lake. The bathhouse was state of the art—water, sewer, and electrical lines were brought out to this area for the first time. To create the beach, a 520-foot-long concrete slab was poured and extended out into the lake 162 feet. A diving platform was also installed. Even though swimming has been prohibited for over 50 years, the diving platform and concrete slab are still visible to lake visitors. Other developments in 1930 included a municipal boathouse at T&P Hill and a fish hatchery built with park labor in an area behind the dam. In 1931, the first shelter house (picnic pavilion) and picnic grounds were built overlooking Dixon Bay. The ovens and picnic units were designed by Laura Yeary Smith, the first female member of the Dallas Park and Recreation Board. Today this area of the lake is known as Stone Tables, named for these stone picnic tables.

Large-scale development of recreational amenities did not occur until 1935, when a Civilian Conservation Corps camp was established at White Rock as part of Pres. Franklin D. Roosevelt's New Deal. The National Park Service created projects for these young men, and the camp itself was built and operated by the U.S. Army. The improvements included the planting of more than 1,500 trees, the construction of a shelter house, two concession buildings, two combination buildings, three latrines, and a lily pond, as well as developing trails, picnic grounds, and a campground. When the United States entered World War II, all the young recruits were automatically enrolled in the army and the CCC camps closed. Winfrey Point was not yet finished when the camp closed, so the park and recreation department had to complete construction.

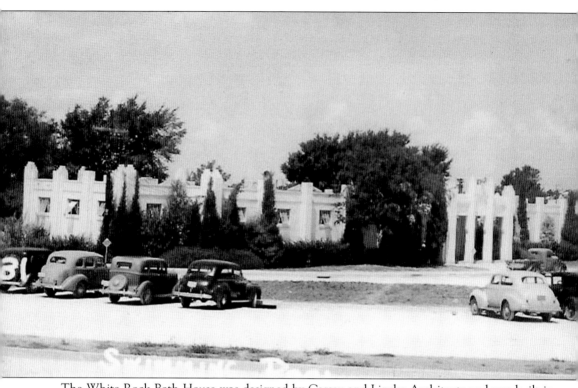
The White Rock Bath House was designed by Carsey and Linske Architects and was built in 1930 at a cost of $48,100. The parking lot was not paved until 1939. Today the bathhouse is a cultural arts center and also houses the White Rock Lake Museum.

The bathing beach at White Rock was popular for decades. In the early years, it was treated as a swimming pool, and staff would go out in a boat to chlorinate the lake. After a few years, a chlorination pipe was laid from the bathhouse to the lake. (Courtesy of the Texas/Dallas History and Archives Division, Dallas Public Library.)

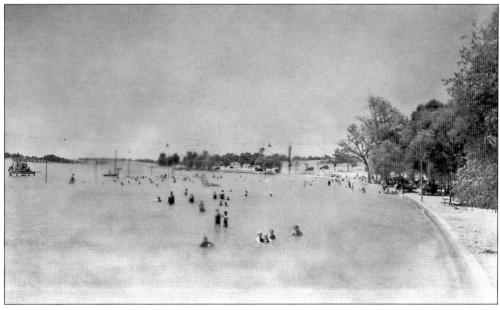

The fish hatchery was first built in 1930 by park labor behind the dam. At the time, there was a Texas state fish hatchery at Fair Park. In preparation for the Texas Centennial Exposition, the fish hatchery at Fair Park had to be removed, and the Texas Game, Fish, and Oyster Commission moved its operation to the fish hatchery at White Rock Lake. (Courtesy of the Texas/Dallas History and Archives Division, Dallas Public Library.)

Earl and Mary Jane Hart are pictured on the east shore of White Rock Lake. Earl Hart worked at White Rock Lake from 1929 to 1943 in various positions. At the time of his death, he was superintendent of White Rock Lake Park. (Courtesy of the Hart family.)

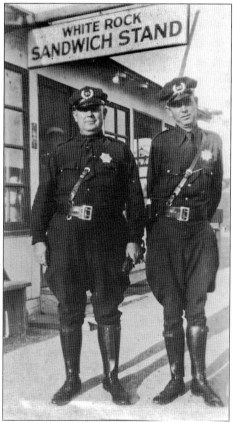

White Rock Sandwich Stand was one of several concession stands at the lake. Earl Hart (left) is pictured with one of his patrolmen at the concession stand. As superintendent of White Rock, Hart was also a certified police officer, as were other members of his staff. (Courtesy of the Hart family.)

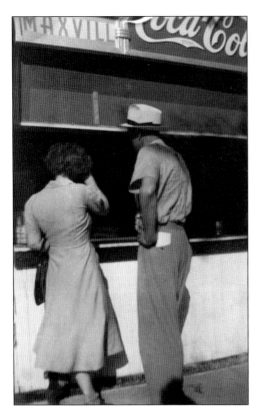

Earl and Mary Jane Hart wait at the concession stand under the bathhouse. There were no grocery stores or restaurants in the area yet, so these concession stands were heavily utilized. (Courtesy of the Hart family.)

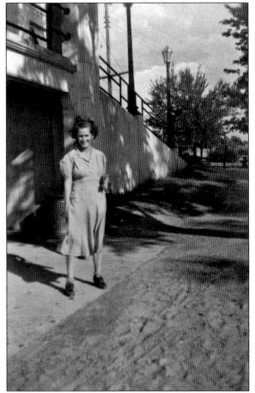

Mary Jane Hart poses outside the bathhouse concession stand. Behind her is the ramp from the bathhouse down to the beach, and sand from the beach is visible at her feet. (Courtesy of the Hart family.)

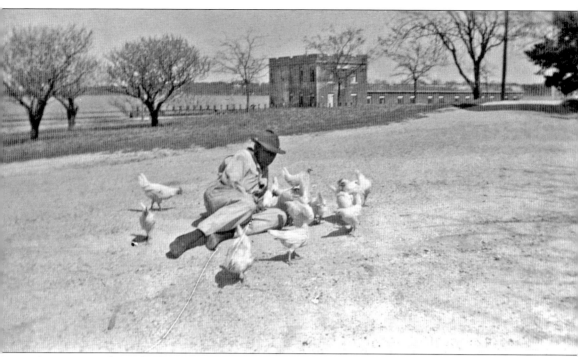

As superintendent of White Rock, Earl Hart lived in a white two-story frame home owned by the city near the pump station. In this picture, Earl is on the ground in front of his home with his chickens. Behind him are the filtration building and the lake. (Courtesy of the Hart family.)

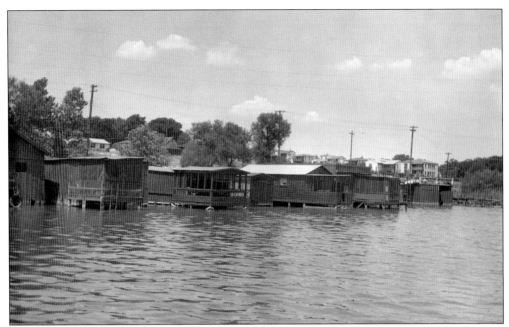

These private boathouses were on the west side of the lake between the pump station and T&P Hill. Behind the boathouses on the right are the new homes on Lakewood Boulevard. To the left, a private summer home is visible on the hillside behind the boathouses.

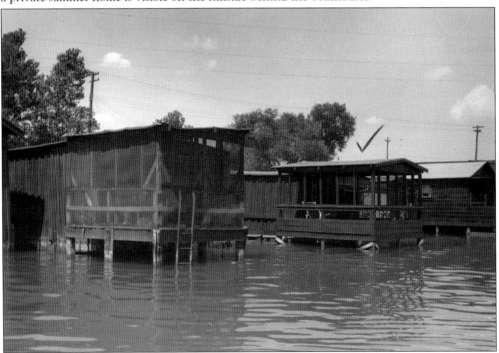

This image shows a close-up of the same private boathouses. Many prominent citizens of Dallas owned these homes and paid a lease to the city of $1 per year. As the park become more popular, lake users believed that these private residences reduced the citizens' access to the lake. The city required that all the private boathouses be removed by October 1, 1952.

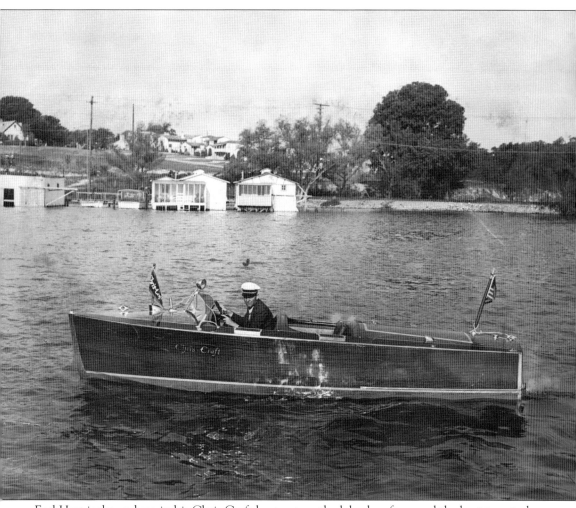
Earl Hart is shown here in his Chris Craft boat out on the lake; he often used the boat to patrol the lake. Behind him are the private boathouses, and behind the boathouses are the homes on Lakewood Boulevard.

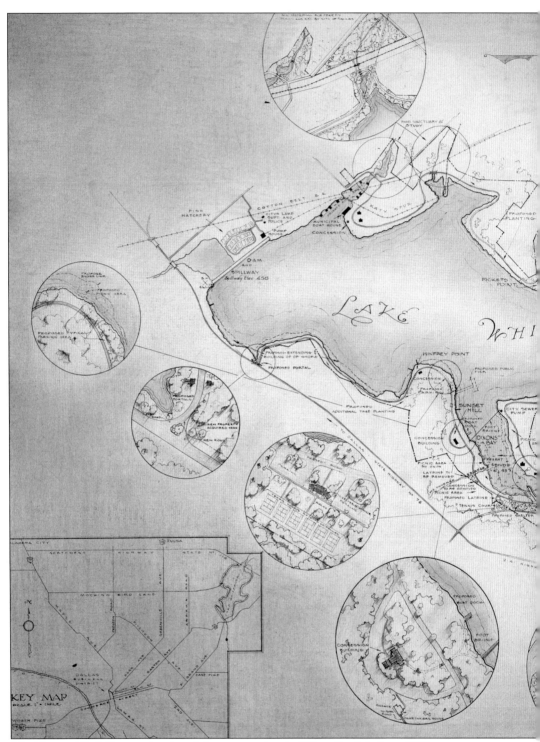

The National Park Service developed this master plan for White Rock Lake in 1935 in preparation for the development of projects for the Civilian Conservation Corps. To the right of the map is the north end of the lake and the newly constructed Northwest Highway. The point just south of

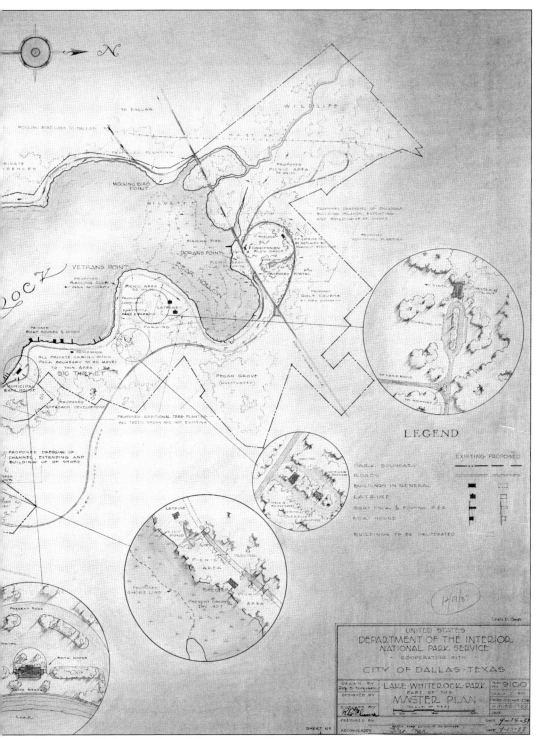

Northwest Highway is Doran's Point, named for former city commissioner William Doran. The large bay on the east side of the lake, which resembles a finger, is Dixon Bay. Today Dixon Bay is silted in almost to the mouth of the bay.

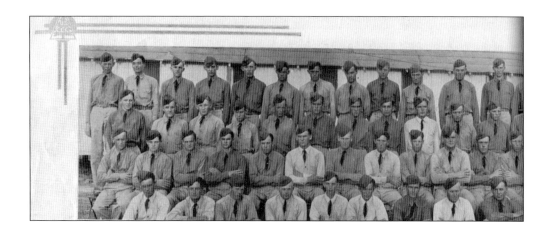

This is the first class of recruits of the White Rock Lake Civilian Conservation Corps (CCC) in 1935. The recruits were to be ages 18–25 and unmarried. Many of the boys, and even more of their mothers, lied about their ages so that they could enter the CCC early. Each young man was paid approximately $30 a month, $22 of which was sent directly home to support his family, which is why many mothers were willing to lie about their sons' age. In the early years, the boys wore hand-me-down World War I uniforms, as seen in these pictures from the 1935 CCC yearbook.

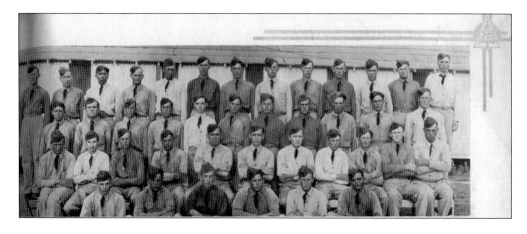

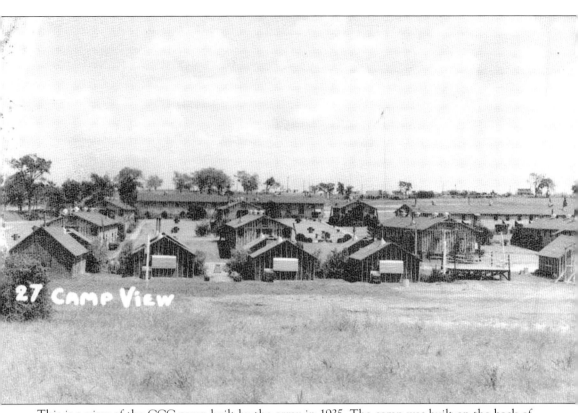

This is a view of the CCC camp built by the army in 1935. The camp was built on the back of Winfrey Point on the east side of the lake. Garland Road (also called State Highway 78) is at the top of the hill behind the camp. The small buildings in the foreground are the hutments used for educational and training programs. If a recruit had not graduated from high school, he was required to go to class in the evenings to earn his GED. (Courtesy of Kathy Smith.)

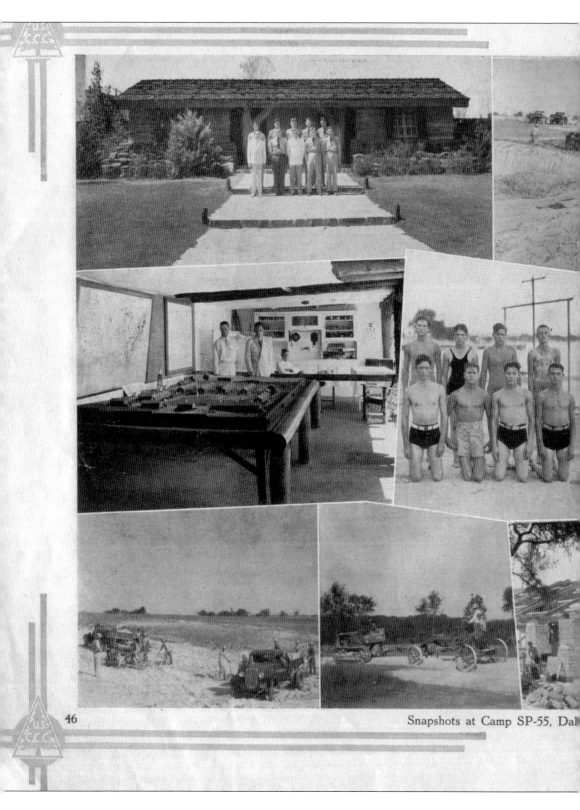

Snapshots at Camp SP-55, Dal

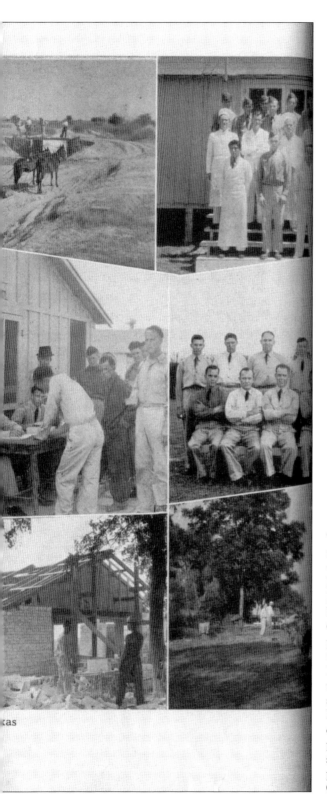

The 1935 CCC yearbook contained this page of projects from the first year of the camp at White Rock Lake. The top two pictures on the left show a CCC exhibit building built at Fair Park for the Texas Centennial Exhibition in 1936. The picture on the left at bottom shows the construction of Doran Circle from Buckner Boulevard toward the top of the hill. The picture second from left at bottom shows the construction of Doran Circle from the top of the hill down toward Goforth Drive. The third picture from the left on the bottom shows the construction of the picnic pavilion at the top of Doran's Point Overlook (called Flag Pole Hill).

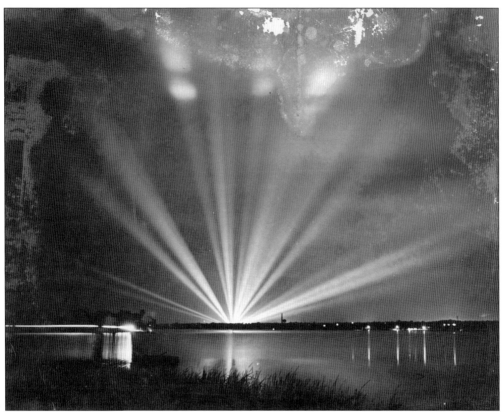

The 1936 Texas Centennial Exhibition at Fair Park had a bank of lights behind the Hall of State that could be seen from as far away as Tyler, Texas. In this picture, the lights can be seen across White Rock Lake. (Courtesy of the Texas/Dallas History and Archives Division, Dallas Public Library.)

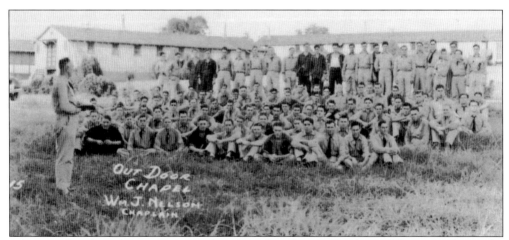

White Rock Lake CCC recruits attend outdoor chapel with Chaplain William J. Nelson. The barracks are pictured behind the young men. (Courtesy of Kathy Smith.)

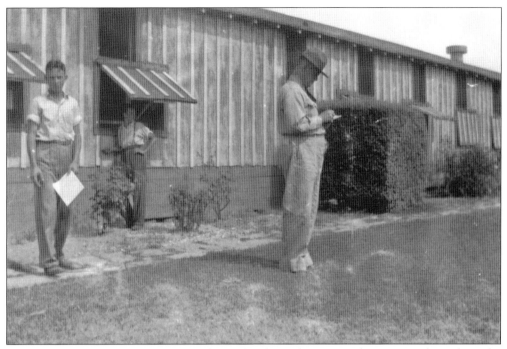

Lt. George Bear and two recruits stand outside a barracks. Notice the vent windows along the wall of the barracks. (Courtesy of Kathy Smith.)

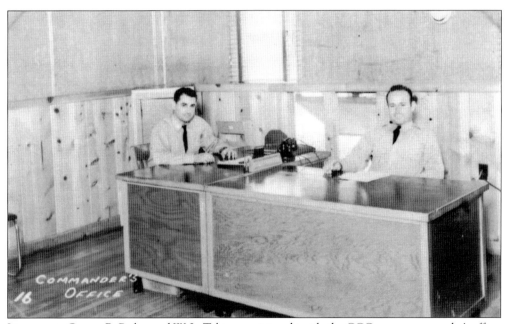

Lieutenants George B. Parker and W. L. Tobin are pictured inside the CCC camp commander's office. Not only was the building built by the army, it appears the desks were also built by the army. (Courtesy of Kathy Smith.)

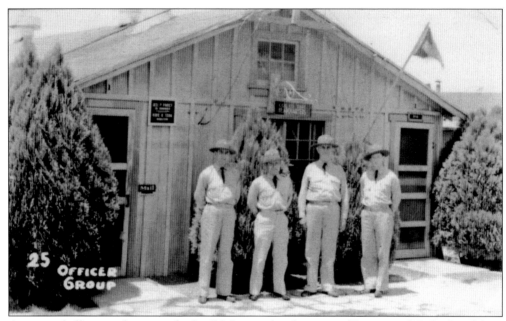

A group of officers gathers outside the CCC camp headquarters. (Courtesy of Kathy Smith.)

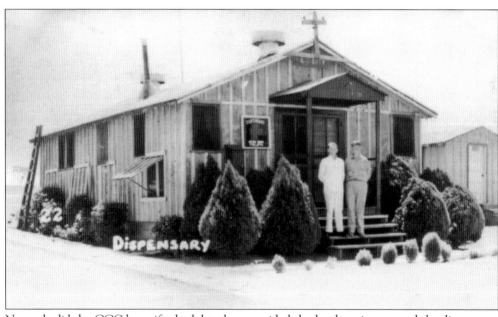

Not only did the CCC beautify the lake, they provided the landscaping around the dispensary. A cot is visible inside the first window of the dispensary. When young men entered the CCC, they were given complete physical examinations. This was often the first time many of them had seen a doctor, dentist, or ophthalmologist. (Courtesy of Kathy Smith.)

Local teachers were hired to provide GED classes as well as other special classes that were requested, and they taught in these educational hutments. The boys could also learn trades in evening classes. The kiosk in the foreground listed the schedule of classes. (Courtesy of Kathy Smith.)

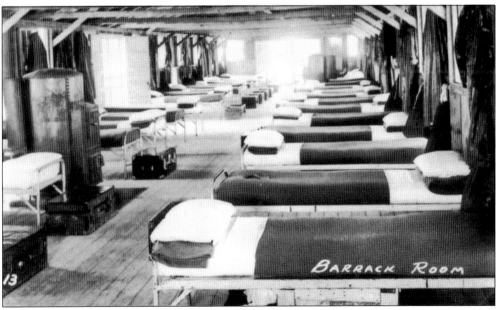

It is easy to see the army influence in these CCC barracks. This may look stark, but the boys at White Rock had very nice facilities compared to some around the country, who were housed in old army tents. (Courtesy of Kathy Smith.)

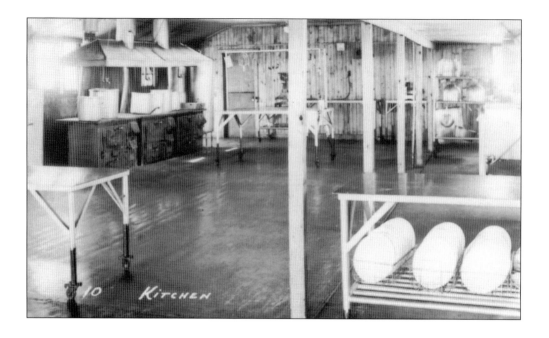

The kitchen was a busy place at the CCC camp, dishing up three meals a day for about 200 young men and officers. Many of the boys who trained as cooks at the camp went on to become cooks in the army during World War II. Below, the kitchen staff lines up outside of the mess hall. (Courtesy of Kathy Smith.)

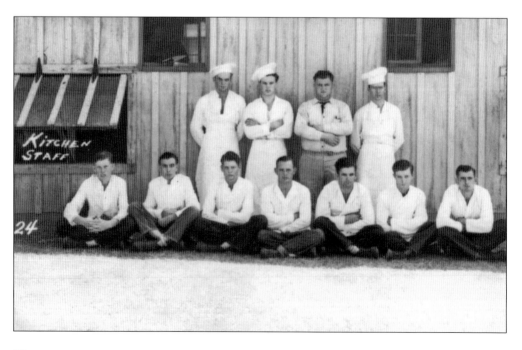

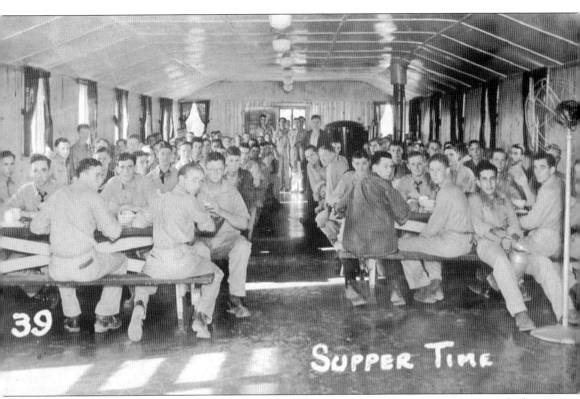

Times were hard during the Depression, and many of the boys were underweight and malnourished when they entered the camp. Most of them bulked up quickly with three full meals and hours of manual labor each day. (Courtesy of Kathy Smith.)

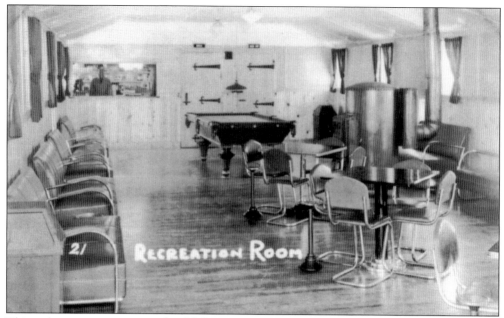

This is the recreation room at the CCC camp. Notice the wrought iron on the doors in the back of the room. This building was later moved to Exall Park in Dallas, where it was utilized as a community recreation center until 1991. (Courtesy of Kathy Smith.)

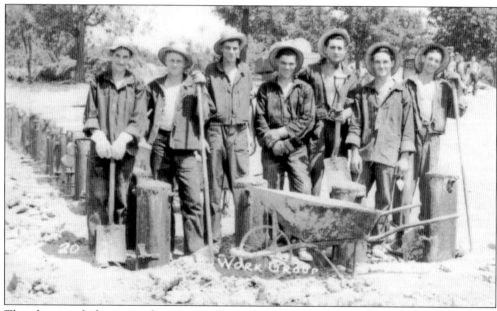

This photograph shows a work group installing concrete bollards around Lawther Drive. Many of these bollards are still in existence around the lake. The big heavy shirts look hot and awkward to be worn by those working in the Texas sun. The boys in the background are not wearing any shirts, so it appears the shirts were put on just for the picture. (Courtesy of Kathy Smith.)

One of the buildings constructed by the CCC at White Rock was the Big Thicket concession building, shown here during construction in 1939. The building has symmetrical porches on both sides of the building with an alcove that looks west over the lake. This is a beautiful place to watch the sunset over the lake. (Courtesy of Kathy Smith.)

Speedboat races were popular at White Rock Lake until the city council passed an ordinance prohibiting boats with greater than a 10-horsepower motor. Boats are pictured lined up at the docks along the northern shore of T&P Hill in 1938.

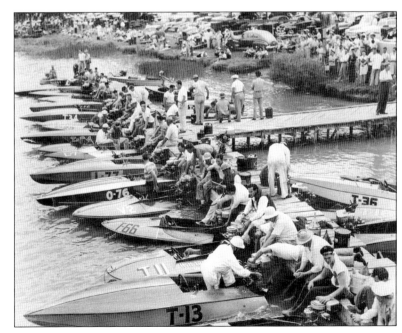

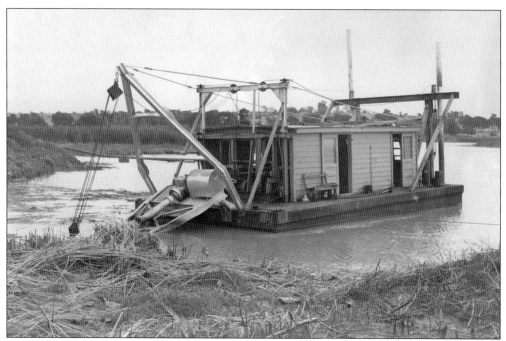

The rate of siltation in the lake has been an issue since the 1920s. The water department purchased this dredge on April 16, 1937, and named it the *Joe E. Lawther*. The park and recreation department began dredging Dixon Bay and the north end of the lake on October 20, 1937.

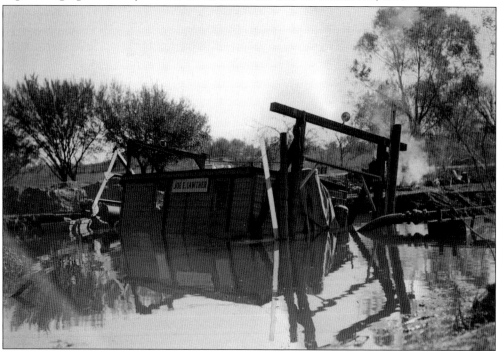

The dredge sank just a month later at 8:30 p.m. on November 17, 1937, while dredging Dixon Bay. A diver from Galveston, Texas, was hired to raise the dredge. He began work at 10:00 a.m. on December 1, 1937, and had the dredge floated by 4:25 p.m. the same day.

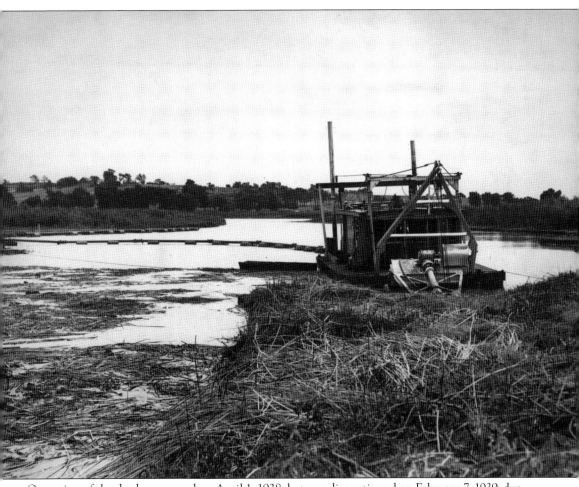

Operation of the dredge resumed on April 1, 1938, but was discontinued on February 7, 1939, due to lack of funds. On July 1, 1939, the park and recreation board assumed the cost of operating the dredge, and it continued operations until October 18, 1941. The dredging reclaimed 68 acres at the north end of the lake and 20 acres in Dixon Bay. At the top of the hill in the background are a barn and house located in what is now Norbuck Park.

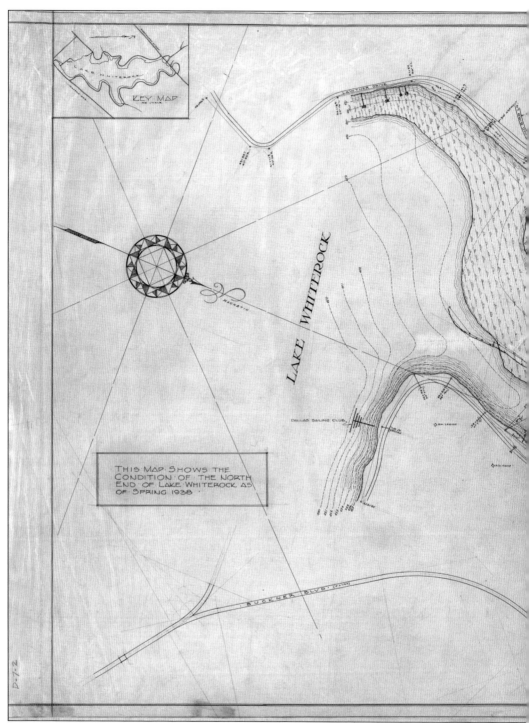

In 1939, the National Park Service issued this map showing the condition of the north end of White Rock Lake in the spring of 1938. To the right are the three branches of White Rock Creek that feed the lake, and the map demonstrates how the flow has changed through the years. In

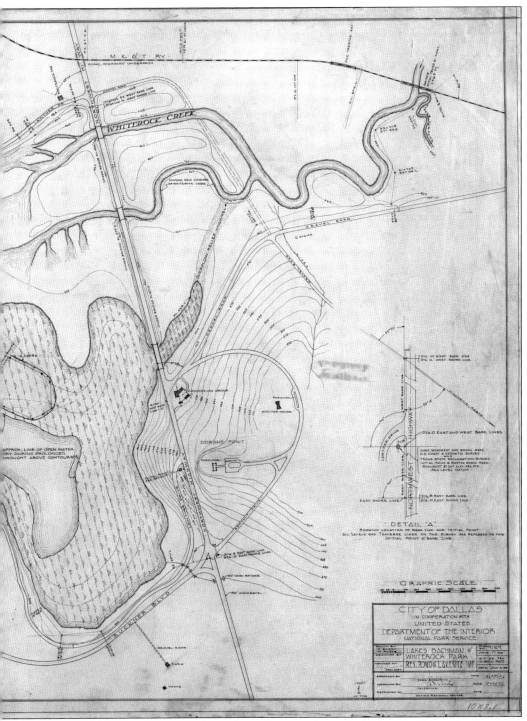

1938, the westernmost branch (at the top) was the main branch of White Rock Creek; the middle branch was the original branch, and the eastern branch was only connected during periods of flooding. Today the eastern branch is the main branch of White Rock Creek.

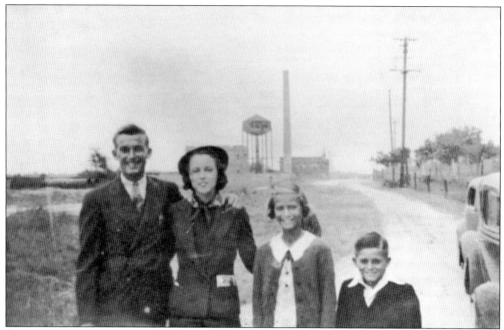

In 1936, Jacqueline Hart worked at the Centennial Exhibition as a Beech Nut girl, and she met a gentleman from Chicago whom she later married. In 1937, her sister Lillian was preparing to take the train to visit her sister, and prior to her departure, the family took these two photographs from the front of their home. Notice the filter building and pump station in the background. Lillian is pictured above (second from left) with her brother Richard, sister Betty Jane, and younger brother John. Below, Lillian is standing with her brother Richard. In this picture, one can see the concrete edges of the filtration tanks.

Earl Hart (at right), superintendent of the White Rock Lake Park, is pictured leaning on his car in front of his house with an unidentified man. As superintendent, he and his family received accommodations in a white two-story frame home on the west side of the lake. Earl's home is on the left, and a private residence is on the right.

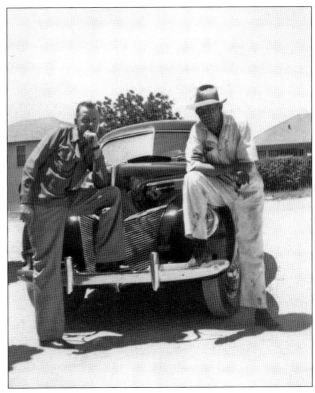

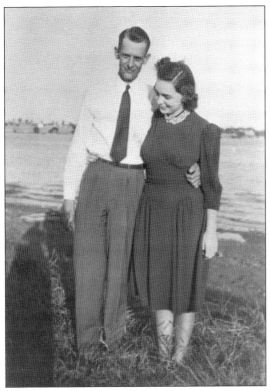

Following their wedding at First Presbyterian Church on September 29, 1939, Paul and Virginia Quillin enjoy an afternoon at White Rock Lake. (Courtesy of their son, Roger T. Quillin.)

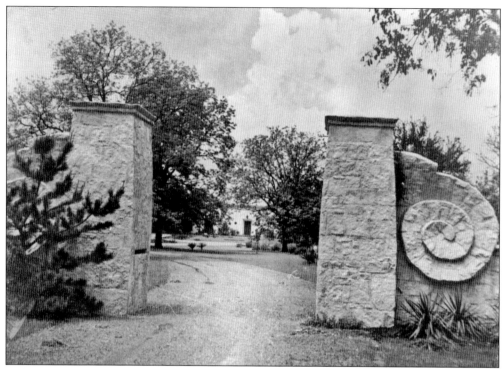

In 1940, internationally esteemed petroleum geologist and explorer Everett Lee DeGolyer purchased 43 acres on the shores of White Rock Lake. DeGolyer commissioned Schutt and Scott to design a Spanish Colonial Revival home he named Rancho Encinal. Through the years, the DeGolyers hosted many distinguished guests at Rancho Encinal ranging from diplomats and cabinet members to sheiks and scholars.

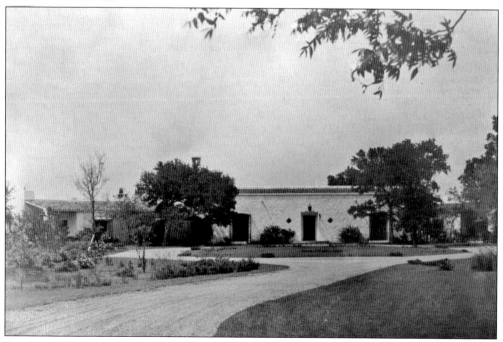

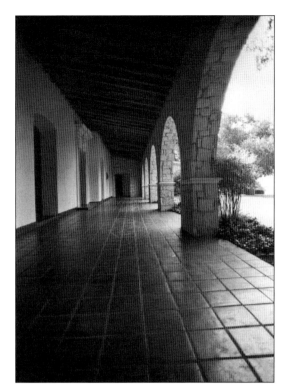

The arcaded porch on the back of the house offers beautiful vistas of the lake.

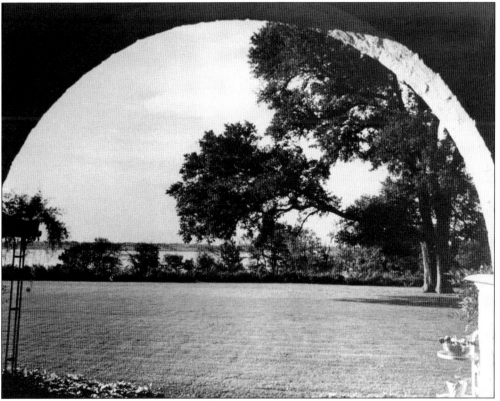

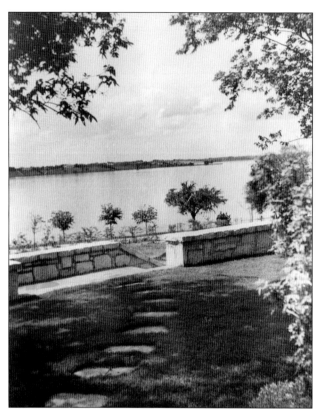

Nell Goodrich DeGolyer dedicated much of her time to developing and maintaining the colorful gardens that surrounded the house. This photograph shows the entrance to the lower gardens near the shores of White Rock Lake.

Everett Lee DeGolyer's library was widely known for its comprehensive materials on a wide variety of historical topics and was reputedly one of the most valuable private collections in the nation. His library was eventually donated to Southern Methodist University.

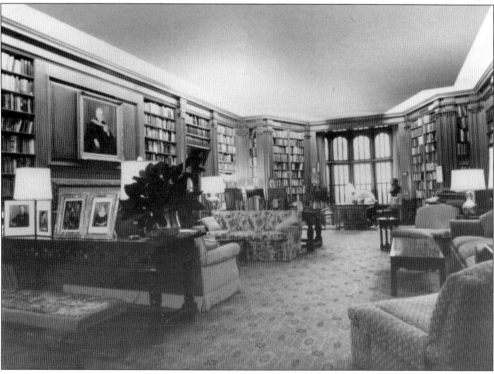

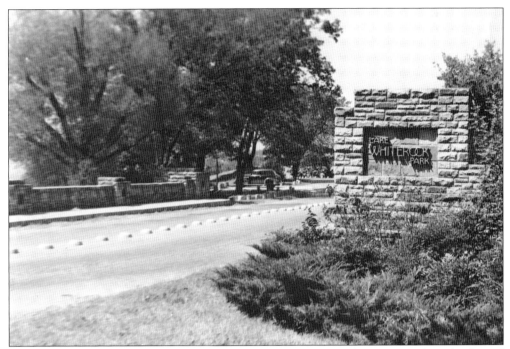

The primary entry portal to White Rock Lake Park at East Lawther Drive and Garland Road (Highway 78) was built by the Civilian Conservation Corps. The architectural style is known as National Park Service Rustic. In developing facilities for parks, the National Park Service wanted to provide facilities without visually interrupting the natural or historic scene. These 1942 images show the entrance sign and bridge, which have changed very little since they were originally built.

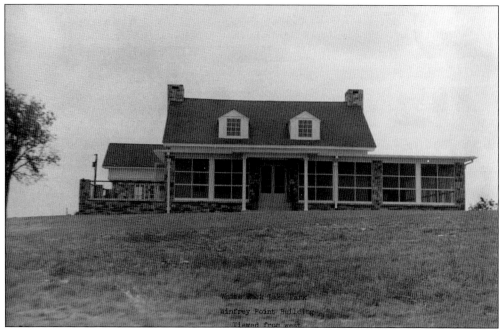

Winfrey Point was the last structure built by the Civilian Conservation Corps at White Rock Lake. Construction was begun on Winfrey Point in 1941 and was not yet complete when the United States entered World War II, forcing the closure of the CCC camp. The park and recreation department assumed completion of the construction on Winfrey Point. In 1942, L. B. Huston, director of the park and recreation department, sent a series of pictures to the regional director of the National Park Service to show the new facility at White Rock Lake. The above picture is the front of Winfrey Point overlooking the lake from its perch at the top of the hill; the lake can be seen from three sides of this building. A large screened porch is located on the front and south sides of the building. The picture below is a view of the south side of the building with a side entrance off of a circle drive.

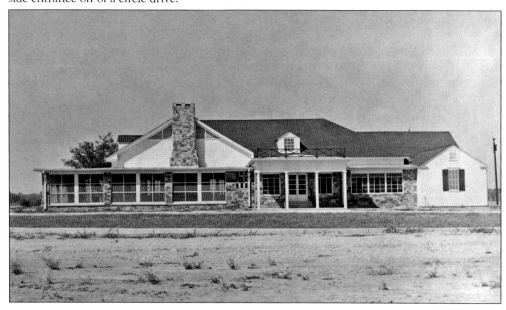

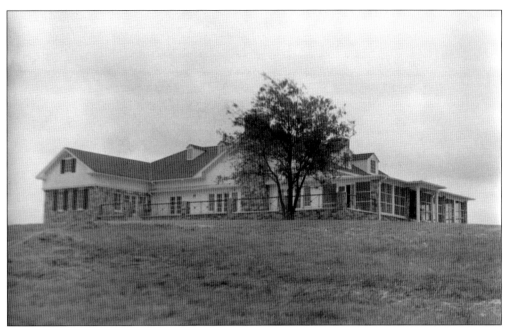

The north side of Winfrey Point provides a large patio overlooking the lake to the north.

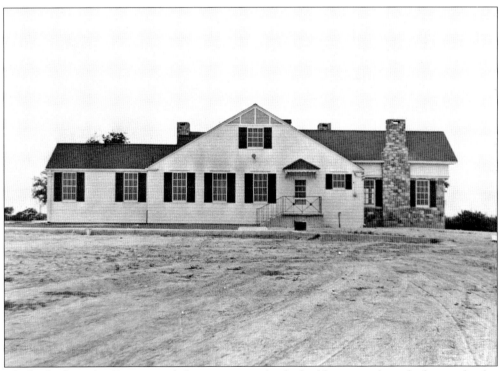

The back of Winfrey Point provided an apartment for the building caretaker, which is used today as Brides Room, an area for the numerous brides who get married at Winfrey Point to prepare for their weddings. The dirt in the foreground is a paved parking lot today.

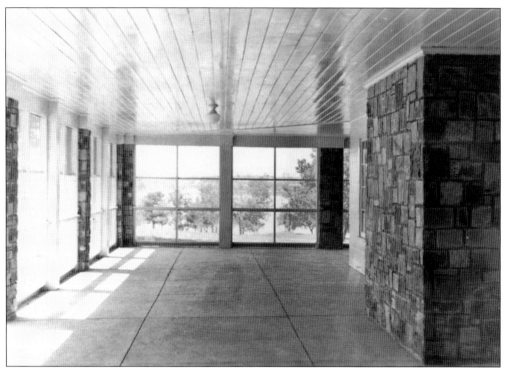

The enclosed porch on the south side of the building provides great ventilation; even in the hot summer months, there seems to be a pleasant breeze on the top of this hill. The lake is visible in the background of the above picture. The photograph below shows the porch facing the back of the building.

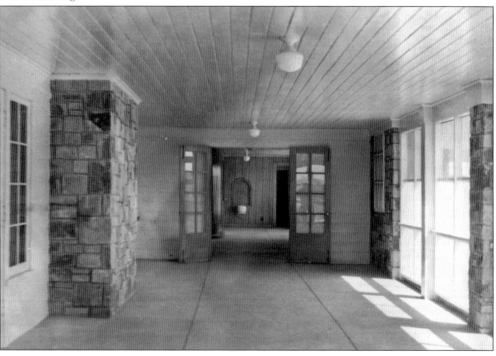

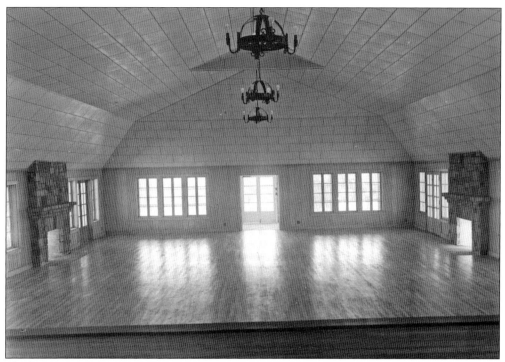

The large main room of Winfrey Point has been the site of family reunions, weddings, school parties and dances, and other community events for decades. It is still heavily utilized today. The above picture shows a view of the large room from the stage looking out toward the front entrance. The photograph below shows a view from the front door looking toward the stage. The doors on the right lead to the south entrance, and the doors to the left lead out to the patio on the north.

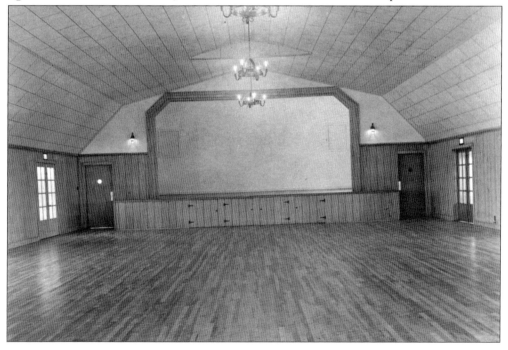

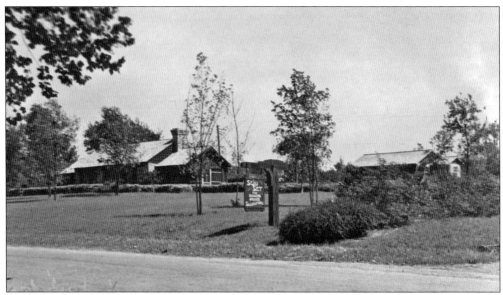

Sunset Inn is a small concession building on the east side of the lake that was constructed by the CCC. The sign out front reads, "Sunset Inn / Dinners Drinks and Sandwiches."

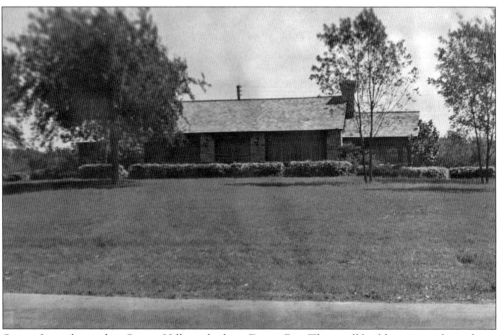

Sunset Inn is located on Sunset Hill overlooking Dixon Bay. The small building expands outdoors with screened porches on both ends of the building and a large front porch.

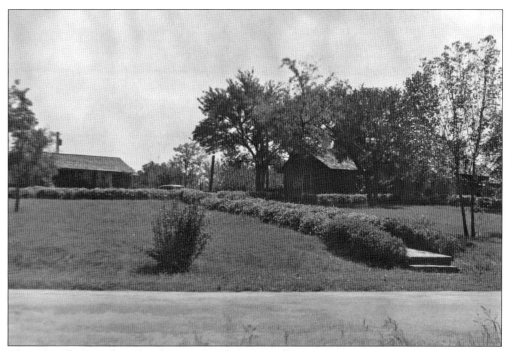

The sidewalk from the side of Sunset Inn led to a walkway across Dixon Bay to Dreyfuss Point. In the background, on the left, is a cottage that was originally built as a caretaker's house and is used today as a park district maintenance office.

Big Thicket is another concession building on the east side of the lake near the sailing clubs, and it was also built by the CCC. The sign out front is very similar to the one at Sunset Inn announcing dinners, drinks, and sandwiches.

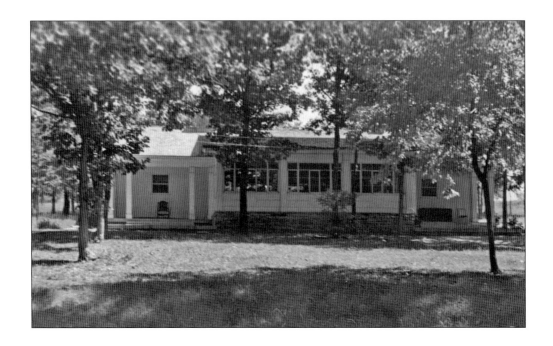

Unlike most of the area around White Rock Lake, the area around Big Thicket is heavily treed. The alcove and porches face White Rock Lake, and it is a beautiful place to watch the sun set across the lake. The four trees in front of the building are in existence today.

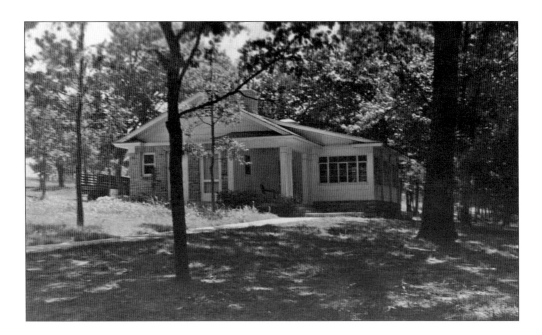

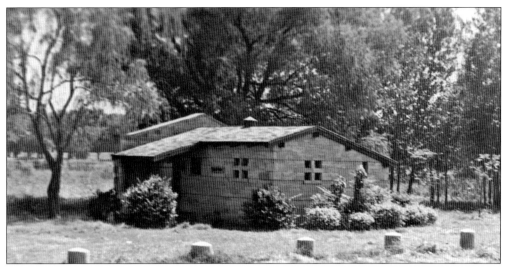

The CCC built three modern comfort stations at White Rock Lake. This comfort station is on the east side of the lake off Dixon Bay. The wrought iron artwork in the windows displays animals of the lake and park.

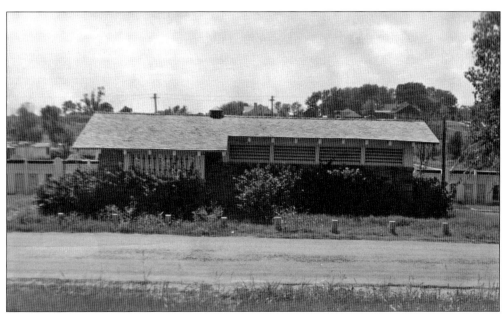

The CCC built this comfort station at T&P Hill. To the left of the comfort station is the top of the boathouse, and on the hill behind the comfort station are several of the private homes that were in the park.

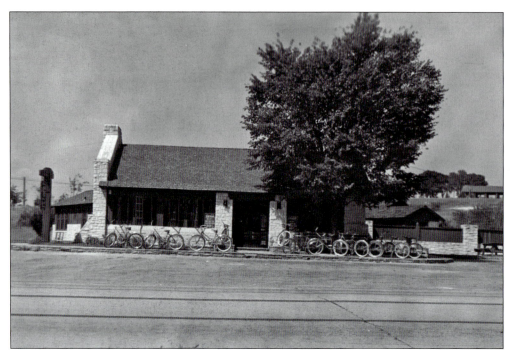

The Doran Combination Building was constructed on Northwest Highway at the foot of Flag Pole Hill. In this 1942 picture, the building was being used as a concession building where one could rent a bicycle for a ride around the lake or buy groceries and bait. At the time of the concession agreement, the closest grocery store was in Garland, Texas. The picture below is a side view of the building. The side building in the foreground is a comfort station, and the building to the right is a garage.

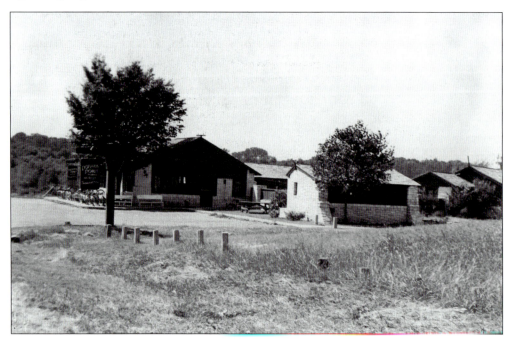

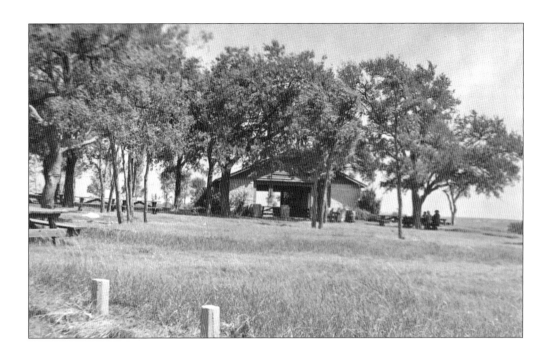

The land that comprises Flag Pole Hill was originally owned by the Goforth family. The Goforths had no use for this rock because nothing would grow on it. Today there are meadows and native prairie grass with just a few trees.

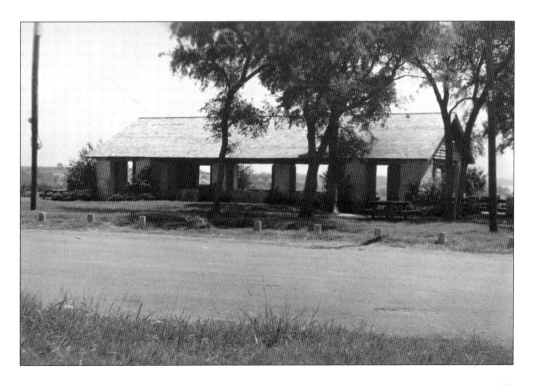

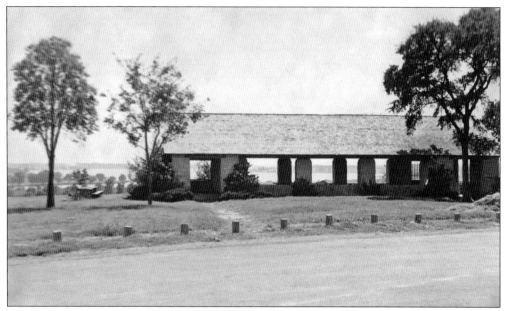

The area that is now known as Flag Pole Hill was originally called Doran's Point Overlook. When the area was first developed in 1935–1936, the lake and Doran's Point were clearly visible from this area 64 feet above the lake.

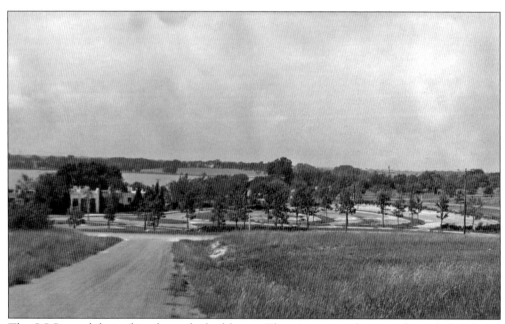

The CCC paved the parking lot at the bathhouse. The young men also transplanted all the trees in the parking lot from a tree farm in Mesquite, Texas. The front of the bathhouse is visible on the left side of the picture.

The concrete bollards installed by the Civilian Conservation Corps outline the parking area along Lawther Drive in this 1942 photograph. Lawther Drive was paved for the first time in 1931. Lawther Drive was later widened and repaved as part of a Works Progress Administration (WPA) program in 1936–1938.

This view from Dixon Branch looks east toward East Lawther Drive. The bridge over Dixon Branch was a WPA project constructed when Lawther Drive was widened and paved.

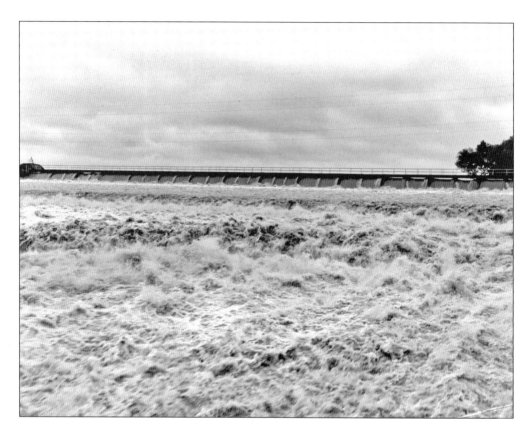

Flooding at the spillway has always held great fascination for people. When there is a large flood in Dallas, people from all over the area drive to the lake just to watch the water rush over the spillway. Today local and national new outlets film the flooding in Dallas from the spillway.

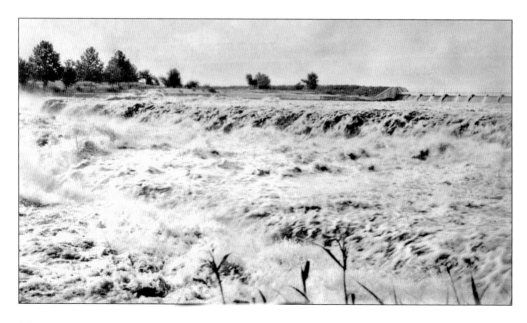

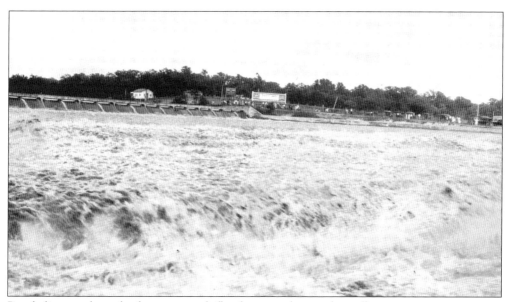

People line up along the fence to watch floodwater rush over the spillway.

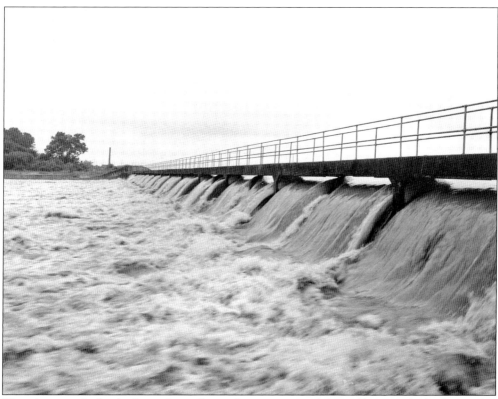

This photograph clearly shows the walkway that once topped the spillway. In the background is the pump station smokestack.

The development of the lake as a park encouraged the city to expand toward the lake. The above picture is the main entrance portal at East Lawther Drive and Garland Road in 1942, looking across Garland Road to an empty lot. The photograph below was taken just a few years later from the same location, and new homes with manicured lots are now visible across Garland Road.

Three
WORLD WAR II AND POST-WAR YEARS
1943–Present

As the United States entered World War II, the enrollees in the Civilian Conservation Corps were automatically enlisted into the U.S. Army, and the camp at White Rock Lake was closed. The park and recreation board was eager to assist with the war effort and entered into a contract with the War Department for free use of the land at the former CCC camp for as long as required. Much to the park and recreation board's surprise, the Army Medical Corps announced that men and women suffering from venereal disease would be brought to Dallas for treatment at White Rock Lake. Neighbors loudly protested and the park and recreation board renegotiated the contract and requested that the War Department look for other uses for the land. The 5th Ferrying Unit then began using the camp for training until more effective quarters were acquired. In the latter years of the war, the camp was used to house German prisoners of war.

After the end of World War II, Southern Methodist University saw a large influx of male students eager to receive an education through the G.I. Bill. There were not enough dormitories to house of all the young veterans. The former CCC camp housed the overflow, and the area became known as Perunaville after the SMU mascot.

The bathhouse and bathing beach continued to be a popular spot until 1953, when Dallas once again found itself in the grip of a severe drought. Dallas Water Utilities had to activate the pumps and start using White Rock Lake for drinking water, and swimming was banned at White Rock Lake. By the time the drought was over, the park and recreation department had begun building modern swimming pools and never reopened the beach at White Rock Lake. As the city continued to grow to the north and east, White Rock Lake became an urban oasis surrounded by a fast-growing city with neighbors on all sides.

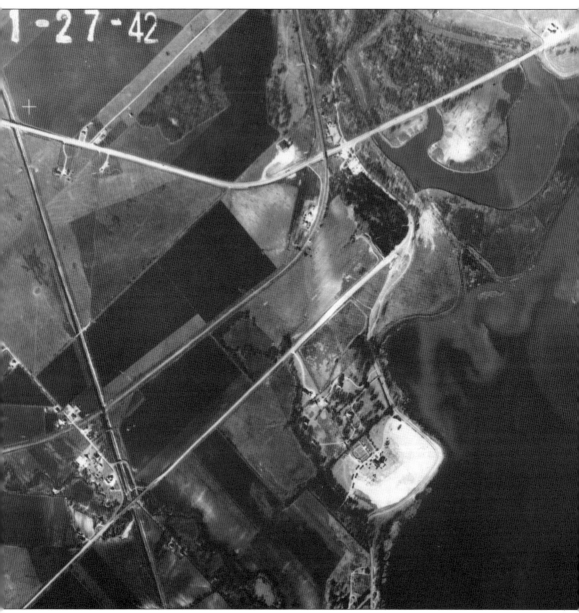

This January 27, 1942, aerial photograph shows the northern section of White Rock Lake. The cloudy areas in the water show the silt flowing in from the north. The road going left near the top center of the picture is Northwest Highway. Today these are the westbound lanes; the eastbound

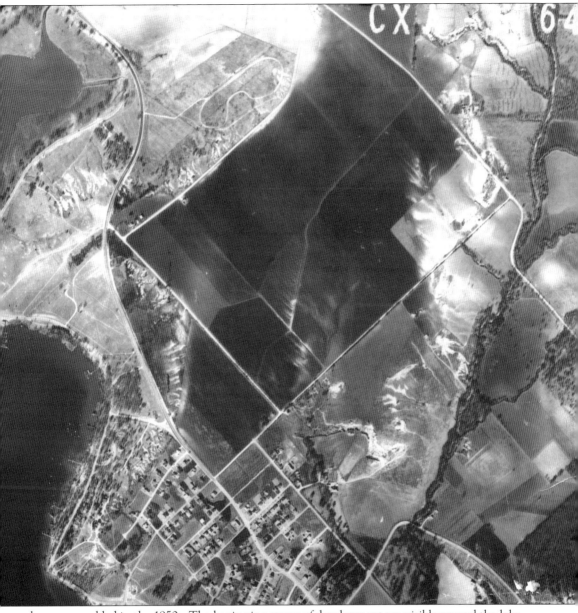

lanes were added in the 1950s. The beginning stages of development are visible around the lake, but it is mostly still open farm land.

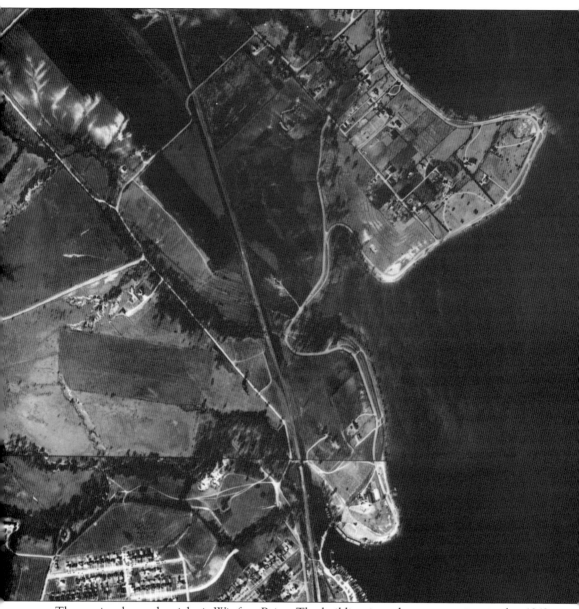

The peninsula on the right is Winfrey Point. The building is under construction in this 1942 photograph. Behind Winfrey Point is the CCC camp. On the opposite side of the lake and close

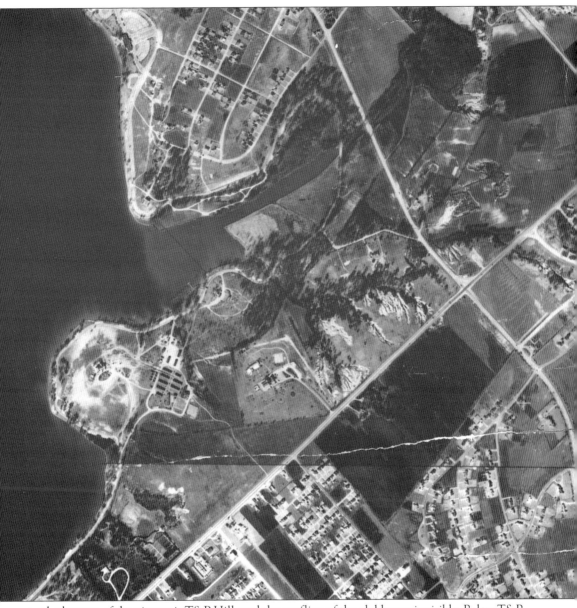

to the bottom of the picture is T&P Hill, and the roofline of the clubhouse is visible. Below T&P Hill on the opposite side of the cove are private boathouses in the water.

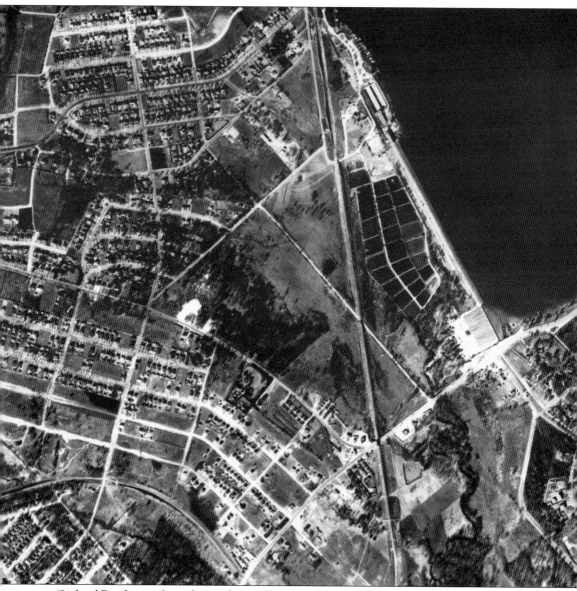
Garland Road runs along the southern edge of the lake and the spillway. On the opposite side of the lake from the spillway is the DeGolyer Estate, which today is home to the Dallas Arboretum.

The Lakewood, Forest Hills, and Little Forest Hills neighborhoods began to develop by 1942.

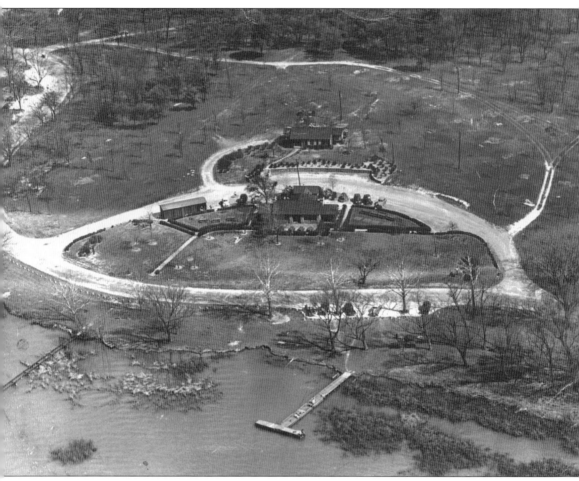

Mary Jane Hart operated a restaurant at Sunset from 1943 to 1945. Above, Sunset Inn is in the foreground, with picnic tables across the front porch and in the gardens to each side. Directly behind the inn and in the parking lot to the left are buildings that were moved from the CCC camp. The house in the background is the cottage where Mary Jane Hart lived with her two younger children. The cottage is now a park maintenance office. In the foreground on the left are the remnants of the walkway that crossed Dixon Bay from Sunset Hill to Dreyfuss Point. (Courtesy of the Hart family.)

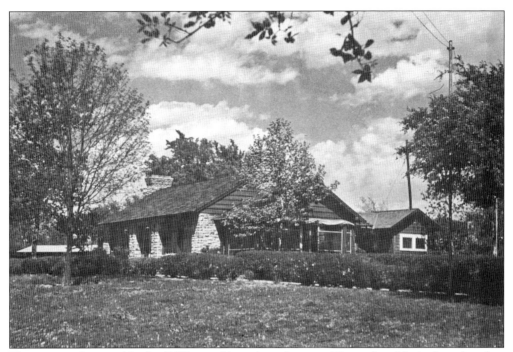

The unique siding used by the CCC is visible in this side view of Sunset Inn. Notice how the edges of each board have the natural shape of the tree from which they came. Behind the inn is one of the CCC camp buildings that were moved to this location. (Courtesy of the Hart family.)

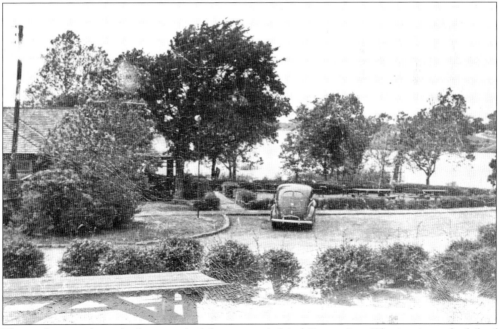

This is the view from the front yard of the cottage behind Sunset Inn. The inn is on the left of the picture, and Dreyfuss Point is visible across Dixon Bay. Dreyfuss Point was named in honor of the Dreyfuss employees' clubhouse, which was on the crest of the point for more than 60 years. (Courtesy of the Hart family.)

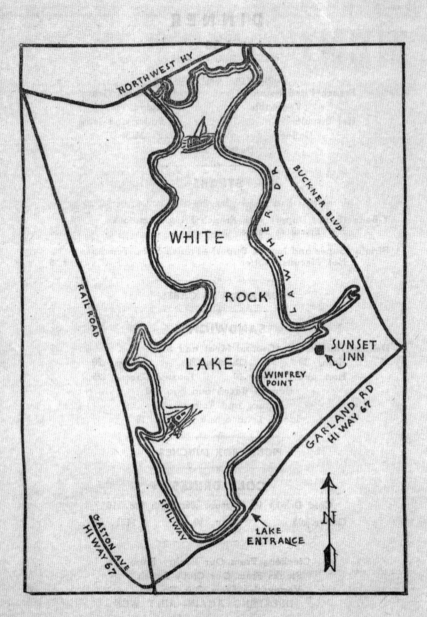

*Best, Best of All Is Sunset on the Lake
At the End of Soul-Delighting Texas Day.*

—Grace Jewett Austin

MEANING: WHAT WE
GOT IF WE AIN'T OUT

See the Sun Set at

NSET INN

★

30 LAWTHER DRIVE ON THE EAST
WHITE ROCK LAKE . . . 1.7 MILES
RLAND ROAD . . . IF YOU GET
FISHING AND HAVE A FISH FRY

★

Catering to

INTMENT SERVICE

F2-0037

11 A.M. TO 11 P.M.—WEEKDAYS
DAY SATURDAY AND SUNDAY
CLOSED MONDAY

MARY HART
PRIETOR - COOK - BAKER
PORTER and ODD JOBS

Shown here is the front and back cover of the menu from Sunset Inn when it was being operated by Mary Jane Hart. (Courtesy of the Hart family.)

BREAKFAST

(Don't Get Up Too Early Cuz We Don't Either)

.65

(This Is a Good Breakfast on Payday)

Choice of Fruit Juice
Ham, Bacon or Sausage
and Two Eggs—Any Style

Hot Biscuits or Toast Butter and Jelly
Coffee Tea Milk

———★———

.55

(This Is OK in the Middle of the Week)

Choice of Fruit Juice
Ham, Bacon or Sausage
and One Egg—Any Style

Hot Biscuits or Toast Butter and Jelly
Coffee Tea Milk

———★———

.35

(Say You're Not Hungry? . . . But It's Probably the Day Before Payday)

One Egg—Any Style

Hot Biscuits or Toast Butter and Jelly
Coffee Tea Milk

———★———

Hot Cakes, .25—With Ham, Bacon or Sausage, .40

———★———

Fresh Orange Juice, .20 Tomato Juice, .15
Grapefruit Juice, .15

———★———

Eggs From Our Poultry Farm—Milk, Cream and Butter From Our Dairy
(WE CAN DREAM, CAN'T WE?)

DINNER
1.50
(Worth Half the Price)

Southern Fried Chicken
Potatoes Cream Gravy
etable Salad
 Butter and Jelly
 Tea Milk
 Dessert Extra

───────★───────

STEAKS
clusively by the Dallas Leather Co.)
r) with French Fries, Tomatoes
, Butter 1.50
ust as Duper)—French Fries, Tomatoes
, Butter 1.50

───────★───────

SALADS A LA CARTE

───────★───────

SANDWICHES
(Ground Meat and Stuff)20
 Cheese, .20 Egg, .20
eese, .40 Toasted Cheese, .25
m or Bacon and Egg, .40
ettuce and Tomato, .20
n, Lettuce and Tomato, .30

───────★───────

PICNIC BOX LUNCHES

───────★───────

COLD DRINKS
ks in Season, .05; With Ice, .10
 Tea, .10 Milk, .08

───────★───────

ens From Our Poultry Farm
ks From Our Cattle Ranch
etables From Our Garden
EAMING AGAIN—AIN'T WE?

───────★───────

FROM THE FINANCE COMPANY
. and We Ain't Kidding

Mary Jane Hart made the best fried chicken, according to her grandson. Check out the prices for breakfast. Mary Jane was not kidding when she said the equipment was owned by the finance company—it was the finance company that came just a few years later to take the equipment away. (Courtesy of the Hart family.)

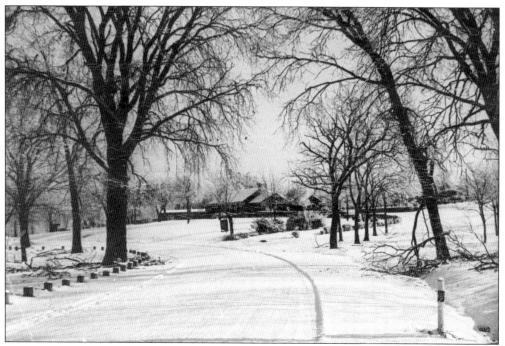

Dallas seldom receives a blanket of snow. This photograph of Sunset Inn in the snow was taken while Mary Jane Hart was operating the inn. (Courtesy of the Hart family.)

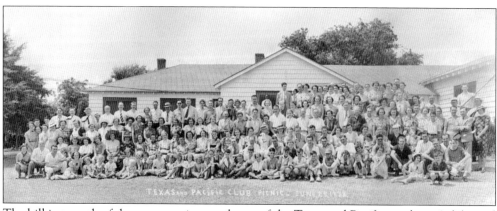

The hill just north of the pump station was home of the Texas and Pacific employees' club until 1942. Until that time, there were numerous private camps and clubhouses around the lake. Many citizens felt that these private clubs limited their access to the lake, so the park and recreation board ruled that all private clubhouses and camps be removed by October 1942. The Texas and Pacific employees' clubhouse was the largest of these private clubhouses, and the location still bears its name.

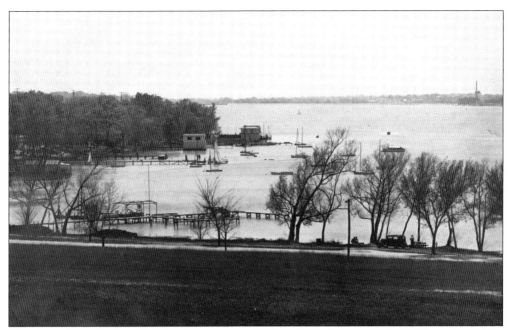

The Corinthian Sailing Club has been a part of White Rock Lake since 1939. The sailing clubs are on the northeastern shore of the lake and are photographed from Boy Scout Hill. In the background on the right is the pump station smoke stack.

This photograph shows one of several fishing piers along the northeastern shore line, with a couple of sailboats anchored nearby.

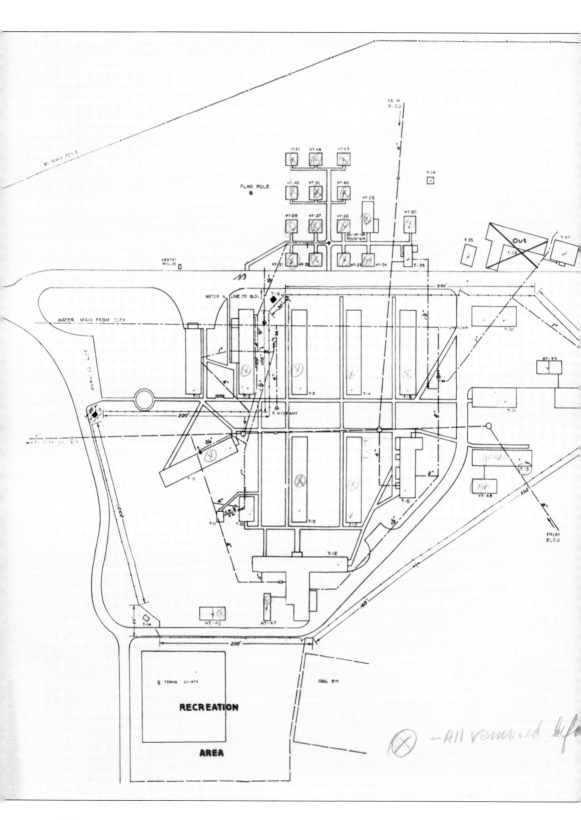

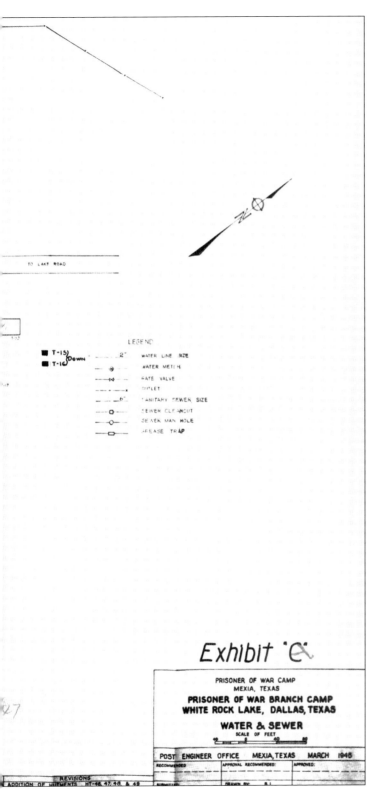

The former Civilian Conservation Corps camp became a branch of the Mexia, Texas, prisoner of war camp, housing German officers from Rommel's Afrika Korps. There was not originally a fence or any type of enclosure around the camp, so the prisoners had to build their own fence with guard towers. The POWs worked at Fair Park mending uniforms and mess kits.

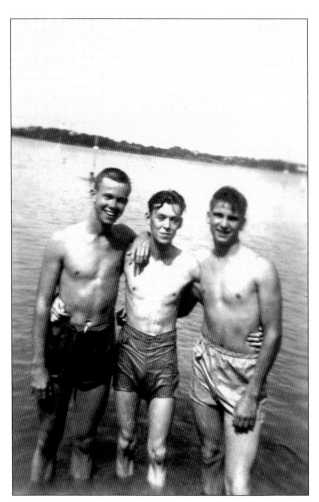

The 1945 class of North Dallas High School held many senior activities at the lake. Pictured from left to right, seniors Lamar Lovvorn, Zeb Landrum, and Martin Lovvorn enjoy a swim at the beach at White Rock Lake. (Courtesy of Betty Pitcock.)

Mary Francis Martin and Bill Martin are enjoying a picnic on Dixon Bay at one of the senior class activities. Sunset Hill is on the opposite shore line. (Courtesy of Betty Pitcock.)

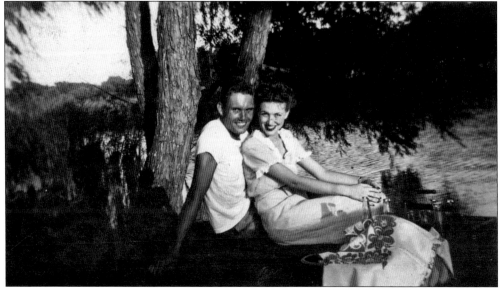

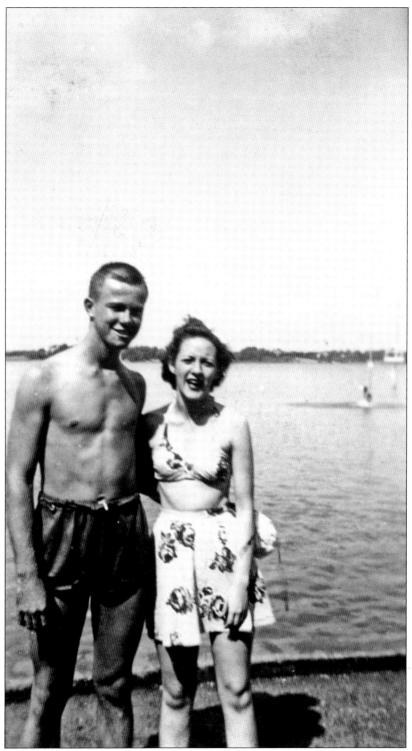
Lamar Lovvorn and Talma Biles are enjoying the beach at White Rock Lake. (Courtesy of Betty Pitcock.)

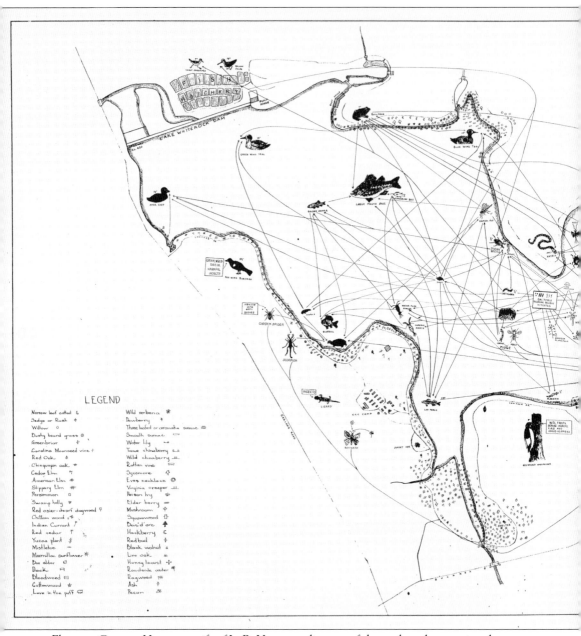

Florence Conway Houston, wife of L. B. Houston, director of the park and recreation department from 1939 to 1973, was taking biology at Southern Methodist University. For a class project,

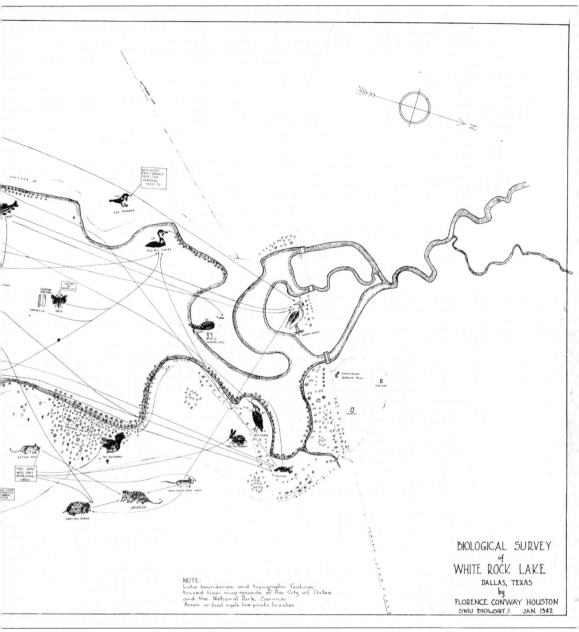

she drew this map of White Rock Lake detailing the flora and fauna with their travel and dietary habits.

This is one of the private boathouses that lined the shoreline. This boathouse was located on the far north end of the lake.

After the war ended, Southern Methodist University experience a large influx of veterans, and there were more male students than university housing could accommodate. Once again, the old CCC camp was utilized to house young men. The camp area was renamed Perunaville after the SMU mascot, Peruna.

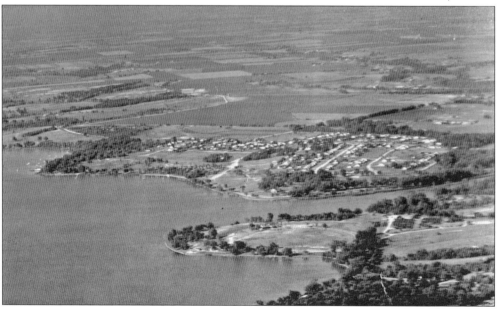

Fishing has been a part of White Rock Lake from the earliest days of the lake. Billy (left) and Johnny Millican are holding the 100-pound catfish that they caught at the lake. (Courtesy of the Hart family.)

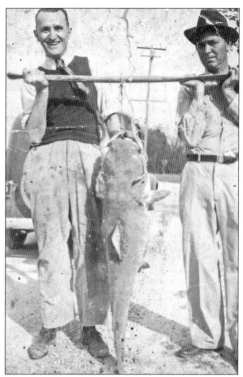

This father-and-son team caught a few fish but none as large as the Millicans.

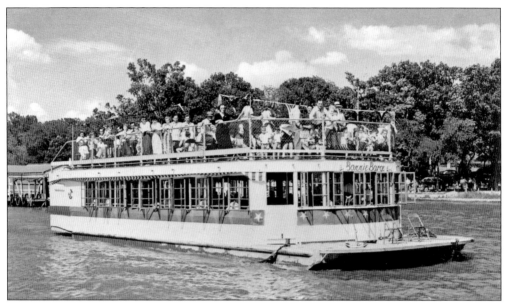

Johnny Williams brought the *Bonnie Barge* to White Rock Lake in 1946 and, for the next 10 years, provided afternoon and moonlight cruises. The barge held approximately 150 people and was a favorite spot to dance or find that quiet, dark corner with a favorite sweetheart. In 1956, the *Bonnie Barge* was sold after the city passed an ordinance limiting boats to a maximum of 10 horsepower.

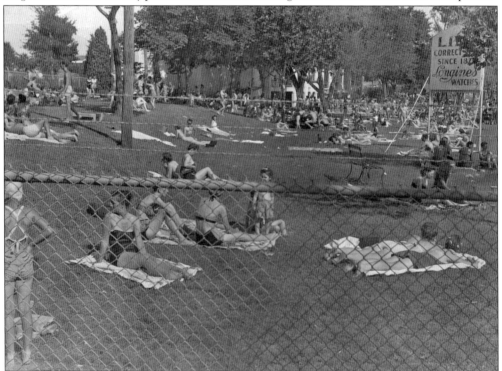

White Rock Bath House and Beach remained a popular swimming hole for nearly 25 years. Originally staff would go out in boats to chlorinate the water for the swimmers, but after a few years, a pipe was added from the bathhouse into the water for chlorination.

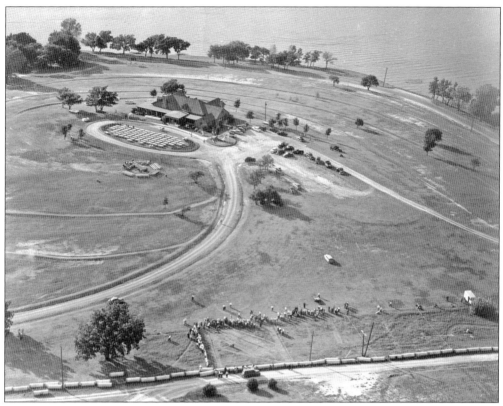

In June 1950, the Dallas Park and Recreation Department hosted the American Institute of Park Executives Association (forerunner of the National Recreation and Park Association) at Winfrey Point. The building was less than 10 years old, and neither the drive nor the parking lot was paved then. One thing has not changed in the decades since it was built: the view from atop this hill overlooking the lake. Dallas Water Utilities was preparing to install a new water line across Winfrey Point; the new pipe is laid out adjacent to the main road that led to the old CCC camp.

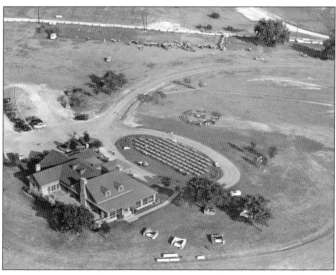

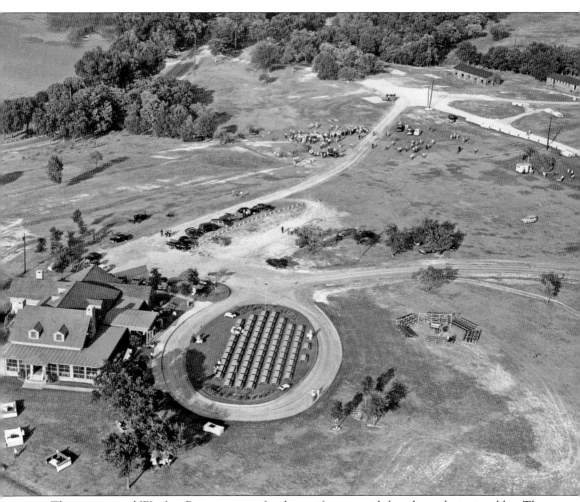

The area around Winfrey Point is set up for the conference with booths and picnic tables. The attendees are gathered in the field watching a demonstration. The last two remaining buildings from the old CCC camp are visible in the upper right of the photograph. By August 1950, these last two buildings had been dismantled and removed.

By 1953, Dallas was once again in a severe drought, and Dallas Water Utilities had to rely on White Rock Lake once again for water consumption. It was at this time that swimming was banned at White Rock Lake.

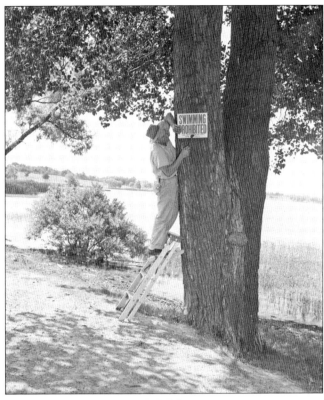

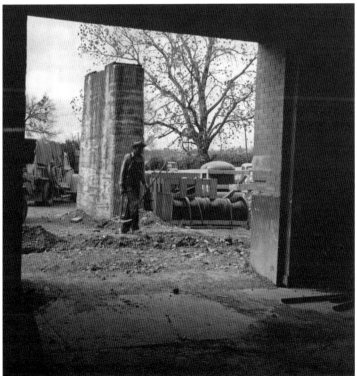

The pump station and filter building had not been used for more than 20 years, and new pumps and pipes were required to bring White Rock Lake back to the condition to be used as a water source. In 1952, workers are preparing the pump station by installing temporary pumping equipment. Outside the door is the old trestle utilized to bring coal to the plant. A train car would be pushed onto the trestle, where the coal would be dropped to the ground and shoveled into the pump station through this open door.

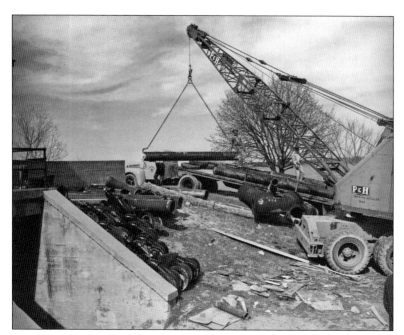

New pipes for the filter building are being unloaded in preparation for renovation of the pipe gallery.

A new 30-inch main is being installed between the settling basin and the pump station. Remnants of the old trestle can be seen outside the pump station.

The dragline covering a section of the newly laid 30-inch main nears the aerators in 1952.

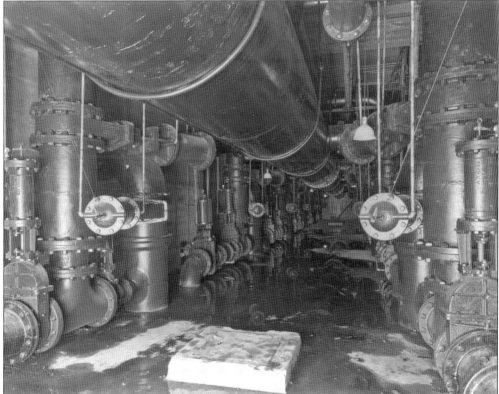

This photograph shows the newly renovated pipe gallery in the filter building in 1953. The new equipment was state of the art, but many residents of this area remember the foul taste and smell of the water that came from White Rock Lake during this time.

By 1956, the drought had left these slips on the east side of the lake completely dry. The concessionaires' boats are stacked up on shore.

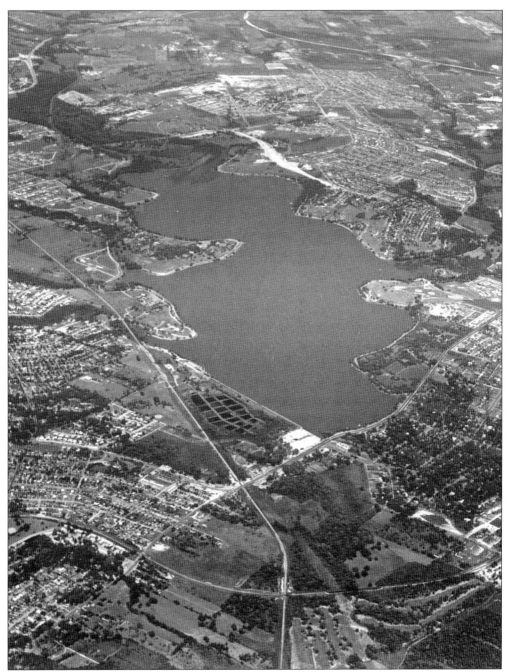

This 1958 aerial photograph shows the spillway and fish hatchery on the southwest side of the lake. On the far northeast side of the lake, the newly realigned Buckner Boulevard is visible by the new concrete, which is extremely white. The realignment straightened Buckner as it approached Northwest Highway.

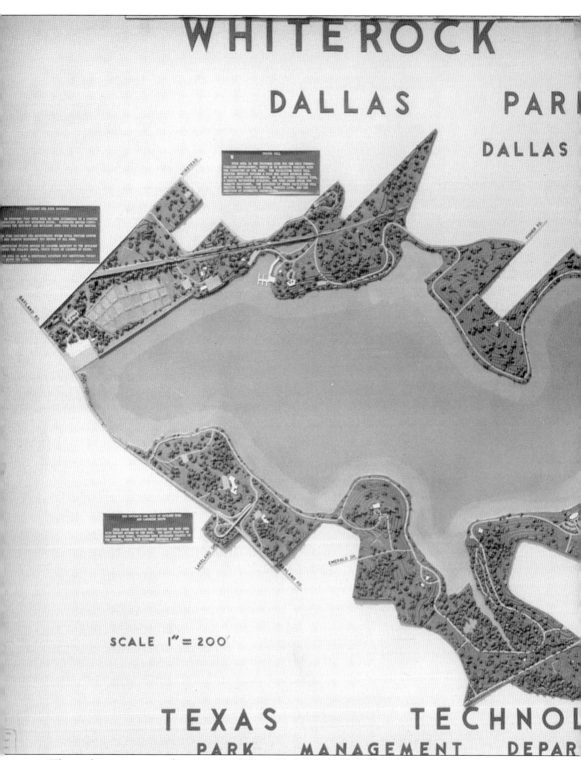

The park management department of Texas Technological College (now Texas Tech University) prepared this master plan of White Rock Lake in the late 1950s. During this time, the City of

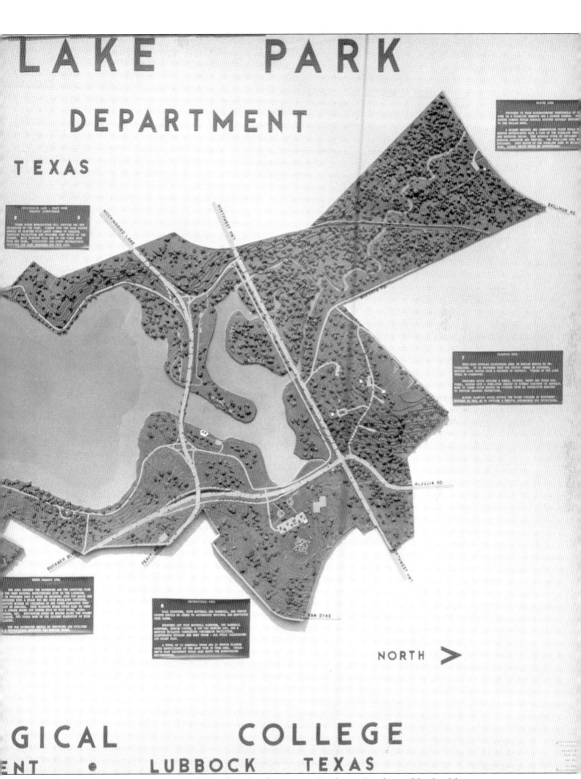

Dallas was preparing to extend Mockingbird Lane to Buckner Boulevard by building a causeway over the north end of the lake.

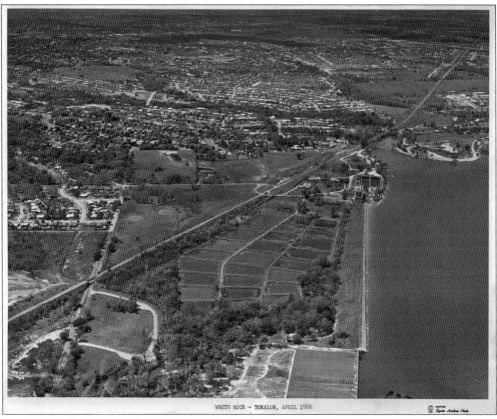

By 1962, Dallas neighborhoods surrounded White Rock Lake. The above picture shows the spillway, dam, and fish hatchery in the foreground with the Lakewood neighborhood back behind the Southern Pacific Railway. The photograph below shows Gaston Avenue in the foreground with Lakewood to the north.

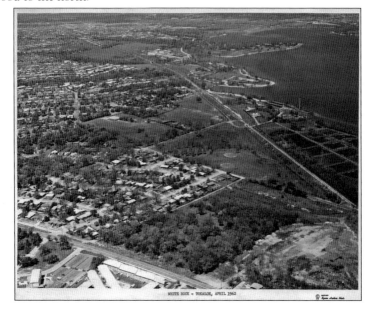

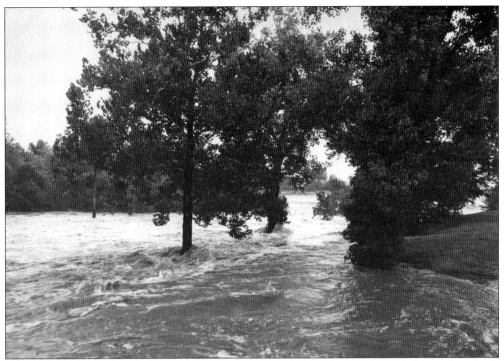

In 1962, Dallas experienced a major flood, which put most of the area surrounding White Rock Lake under water. Dixon Branch is shown flowing swiftly into Dixon Bay.

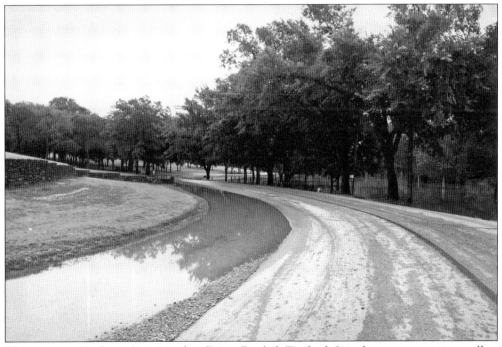

This photograph shows East Lawther Drive flooded. To the left is the stone retaining wall at Dreyfuss Point that was constructed by the WPA, and across Dixon Bay in the background is Sunset Hill.

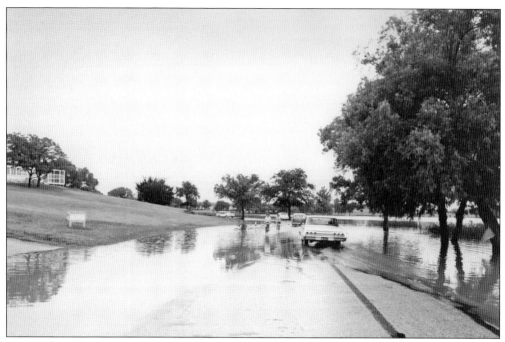

Cars and cyclists attempt to forge East Lawther Drive. Dreyfuss Club is on the top of the hill on the left and was the last of the private clubs at White Rock Lake. The Dreyfuss employees' club sold the building to the Dallas Park and Recreation Department, and it was used by the community for many years.

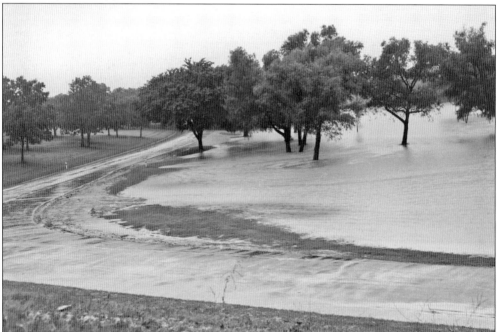

This flooding picture was taken from Buckner Boulevard looking down on East Lawther Drive. The right-angle turn on East Lawther Drive was created when Buckner was realigned and East Lawther Drive was rebuilt in this area.

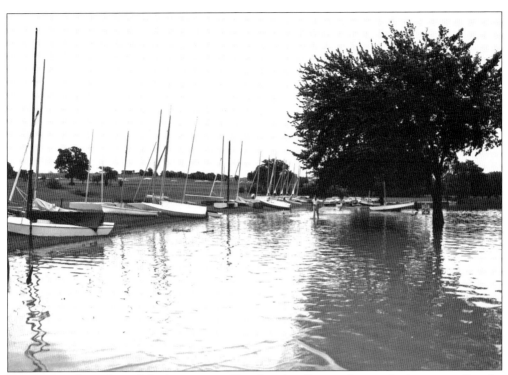

Flood waters have floated the boats across East Lawther Drive, where only six years earlier the boats were stranded on dry land after the water receded during the drought.

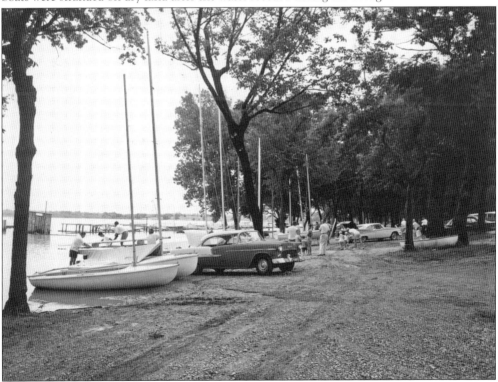

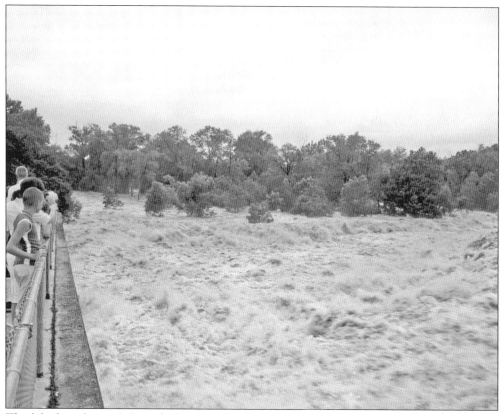

The lake has changed through the years, but one thing has not: everyone still gathers at the spillway to watch the floodwater flow past.

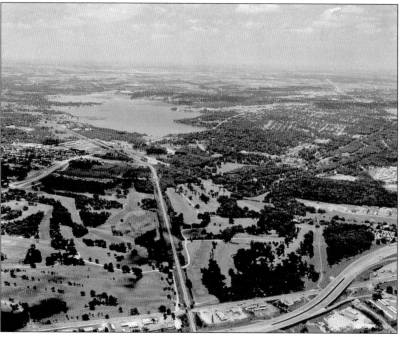

Tenison Golf Course was the city's second golf course and is on land donated by Edward O. and Annie Tenison in honor of their son in 1921. The golf course is on White Rock Creek, just south of White Rock Lake.

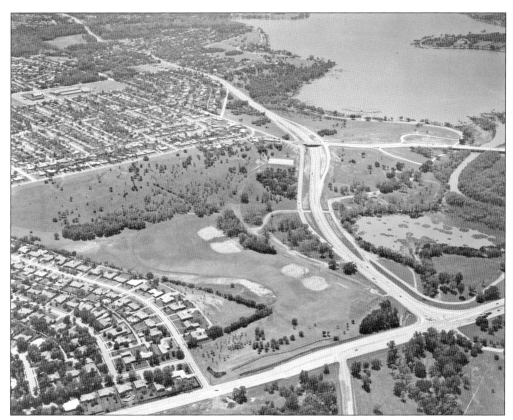

Norbuck Park, located at the intersection of Northwest Highway and Buckner Boulevard, was part of the original land purchased for White Rock Lake. The parking lot of Norbuck Park was the original Buckner Boulevard. Follow the line from the parking lot up the hill to see the original route. On the other side of Buckner Boulevard, Doran's Point is visible.

In 1965, Mockingbird Lane was extended to Buckner Boulevard with a bridge over the north end of White Rock Lake. In this photograph, the silting at the north end of the lake where White Rock Creek flows into the lake can be seen.

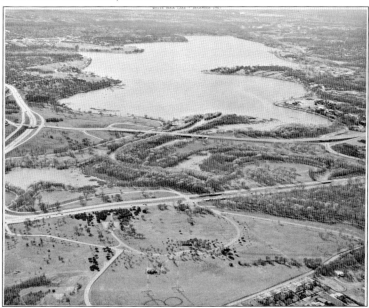

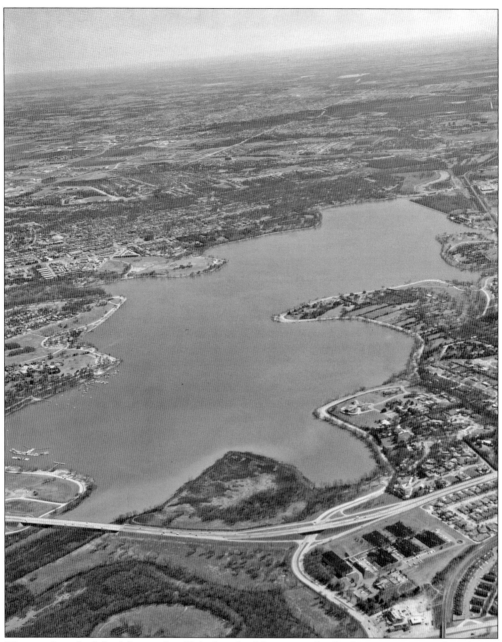
The north end of the lake south of Mockingbird Lane was dredged again in 1974. The silt was not hauled off but was used to create Mockingbird Point. Compare the before and after with the photograph on the previous page.

In the 1960s and early 1970s, cruising became a real problem on the weekends. It would often take more than an hour to drive the few miles from Garland Road north to Mockingbird Lane. In an effort to control traffic, East Lawther Drive was converted to one-way traffic, but this picture shows the cars at a standstill near the bathhouse.

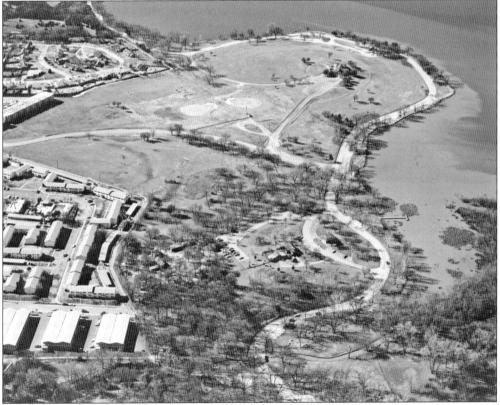

Two baseball diamonds have replaced the old CCC camp at Winfrey Point, and Emerald Isle created a new entrance to the lake from Garland Road. The old cottage where Mary Jane Hart had once lived with her children is now a park maintenance office. Some of the sheds from the service yard are visible through the trees.

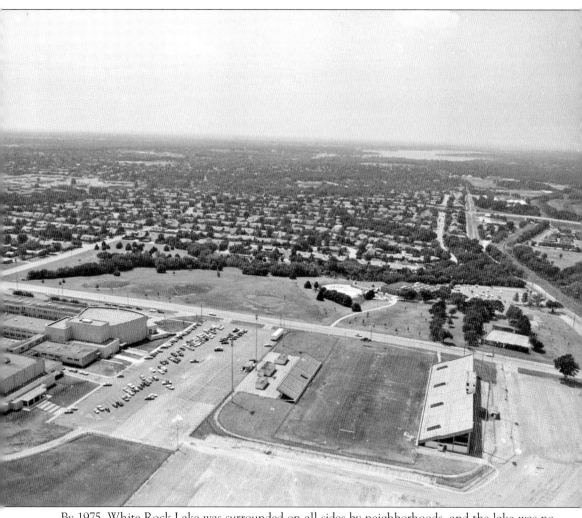

By 1975, White Rock Lake was surrounded on all sides by neighborhoods, and the lake was no longer located in the suburbs but was an urban lake close to the heart of the city. In the foreground is Lake Highlands High School with Lake Highlands North Park across the street. On the horizon and to the south of the school is White Rock Lake.

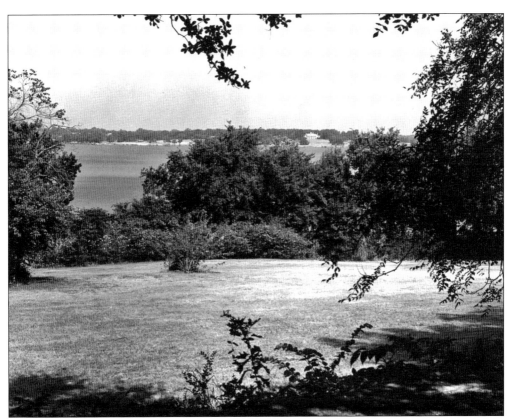

In 1976, the City of Dallas Park and Recreation Board paid $1,076,000 for the 43-acre DeGolyer estate. A special committee was appointed to begin an extensive study of the best uses for the famous estate that overlooked White Rock Lake. Nell Goodrich DeGolyer had established lush gardens throughout the property, so it was fitting when the Dallas Arboretum and Botanical Society began operating the estate as the Dallas Arboretum in 1984.

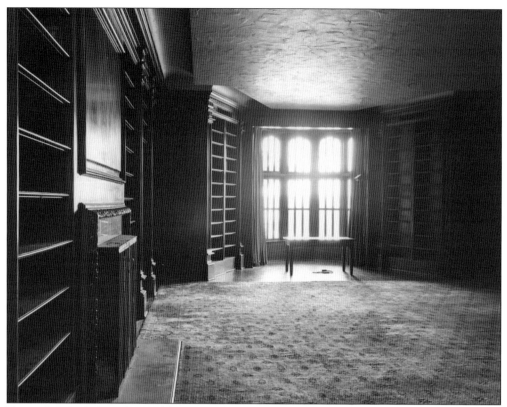

Everett Lee DeGolyer's famous library stands vacant; all of his books were donated to the Southern Methodist University Library upon his death. The bay window at the end of the room overlooks White Rock Lake. The bookshelves on either side of the bay window open to reveal small storage areas behind them.

The Dallas Museum of Natural History operated the Trailside Museum at Sunset Inn for a number of years. The small museum had exhibits of the birds, mammals, reptiles, fish, insects, wildflowers, trees, rocks, minerals, and fossils of White Rock Lake.

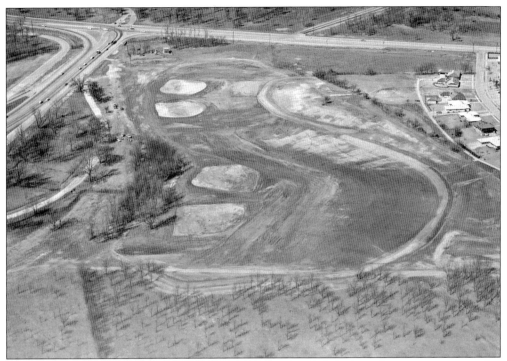

Through the years, some of the fringe areas of White Rock Lake have become separate parks. After Buckner Boulevard was realigned and expanded to six lanes, the area south of Northwest Highway and east of Buckner Boulevard became known as Norbuck Park. Four new baseball diamonds and a new parking lot are being constructed on the old Buckner Boulevard.

Doran's Point Overlook was renamed Flag Pole Hill because of the large flag that flies from the overlook at the top of the hill. Jerry Foote is welding the flagpole after it had been damaged.

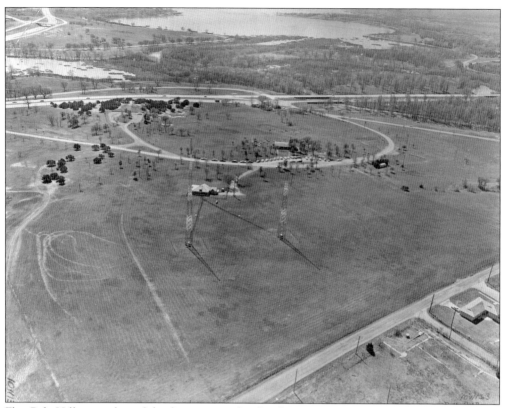

Flag Pole Hill is another of the fringe areas that has become a separate park. Originally White Rock Lake's shoreline extended north of Northwest Highway, and now, as a result of siltation, the shoreline is south of Mockingbird Lane. Because of its high elevation, Flag Pole Hill was home to a variety of radio towers. The street in the foreground above is Lanshire Drive, which was known as Mockingbird Lane up through 1950.

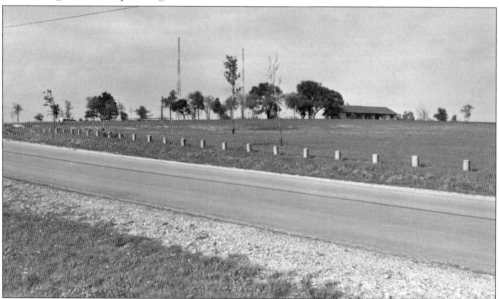

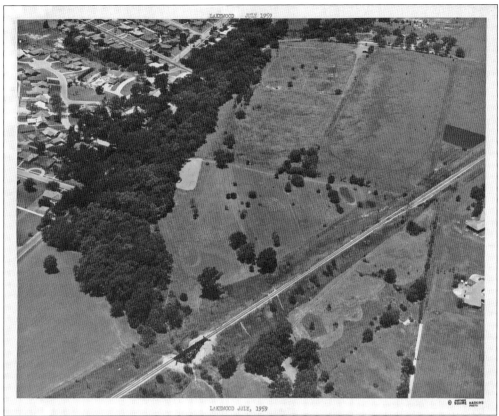

L. B. Houston, director of the park and recreation department, sent out a memo on June 17, 1955, stating that the recently developed picnic area on the east side of Williamson Road, which is a part of the White Rock fringe area between Alexander Drive and Bob-O-Links Drive, would be known as Lakewood Park. In the 1959 photograph above, the picnic facilities are hidden in the trees. By 1969, the area and the park have developed a little more, as seen below. In the upper left corner is Northridge Presbyterian Church, located on Bob-O-Links Drive.

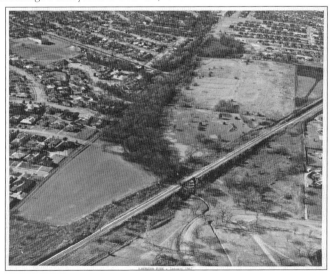

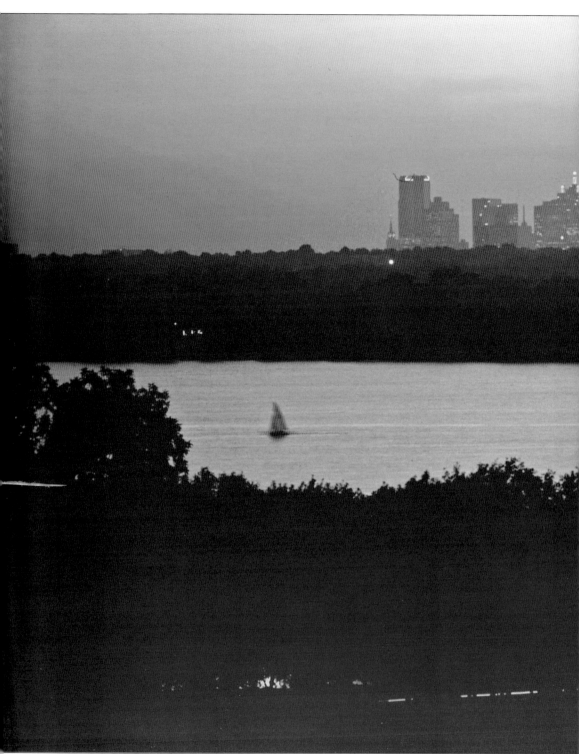

Today White Rock Lake is truly an urban oasis located in a large metropolitan city. It serves over two million visitors a year who come to enjoy its beauty and nature while enjoying

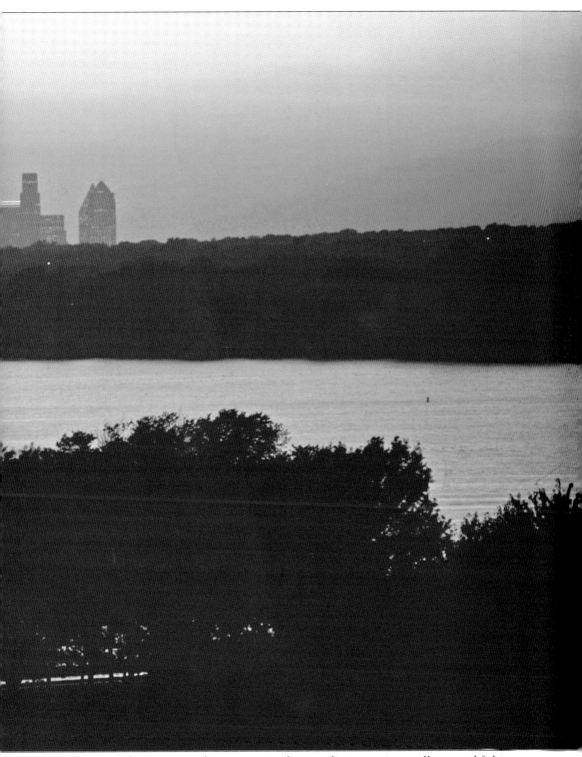
various recreational activities such as rowing, sailing, cycling, running, walking, and fishing. (Courtesy of Jacobs Company.)

Discover Thousands of Local History Books
Featuring Millions of Vintage Images

Arcadia Publishing, the leading local history publisher in the United States, is committed to making history accessible and meaningful through publishing books that celebrate and preserve the heritage of America's people and places.

Find more books like this at
www.arcadiapublishing.com

Search for your hometown history, your old stomping grounds, and even your favorite sports team.

Consistent with our mission to preserve history on a local level, this book was printed in South Carolina on American-made paper and manufactured entirely in the United States. Products carrying the accredited Forest Stewardship Council (FSC) label are printed on 100 percent FSC-certified paper.